Guide

# Flash
## raphy

inolta Corporation
Ramsey, New Jersey

bleday & Company
Garden City, New York

**Minolta Corporation**
Marketers to the Photographic Trade

**Doubleday & Company, Inc.**
Distributors to the Book Trade

This book and the other books in the Modern Photo Guide Series were created and produced by Avalon Communications, Inc. and The Photographic Book Co., Inc.

Library of Congress Catalog Card Number: 82-70158
ISBN: 0-385-18150-7

*Cover and Book Design:* Richard Liu
*Typesetting:* Com Com (Haddon Craftsmen, Inc.)
*Printing and Binding:* W. A. Krueger Company
*Paper:* Warren Webflo
*Separations:* Spectragraphic, Inc.

Manufactured in the United States of America
10 9 8 7 6 5 4 3 2 1

# Contents

**Technique Tips**

Throughout the book this symbol indicates material that supplements the text and which has been set off for your special attention. You can apply the data and information in these Technique Tips immediately to get better results in your photography.

# Introduction

At one time or another you will need to rely on artificial light to aid your photography. The only natural light is sunlight—even moonlight is really sunlight bouncing off a very distant reflector. Otherwise, your illumination is all from artificial sources: street lamps, room lights, candles, and many other sources. Photographers who insist they work only in "existing light" often forget this.

The light from a flash unit or flashbulb is also artificial light. But if you have been smart enough to bring flash to your subject, it too is potentially part of the existing light—flash exists for you to use as you need it, and you should take advantage of every opportunity to put it to work. In fact, many kinds of pictures are impossible without flash—not just technically because you need extra light for proper exposure, but expressively as well: only flash lighting will give the special quality you want in the image.

With few exceptions, electronic flash and flashbulbs are the most "natural" of light sources. Their color temperature closely matches that of the sun, so when you use them indoors with daylight type color film, your pictures return from the processor with well-balanced colors. If you use the same film with the tungsten lamps commonly found in your home, your pictures will have a red-orange cast. If you use the same film with fluorescents, your pictures will appear blue-green—not a pleasant effect for skin tones. Without flash, every time you wanted to take a picture indoors using artificial light, you would have to switch to a film balanced for that purpose or juggle with a filter which could make the light compatible with your film. Flash frees you from those concerns.

The key to using flash is to learn how to control the light for the effects you want. Sometimes that means making flash supplement and imitate the existing light in order to appear as natural as possible—so that the fact that flash was used can't be seen in the picture. In other cases, controlling flash means exactly the opposite. It means creating effects that are very artificial and strange, effects that result from the creative use of light in ways that occur only to an imaginative photographer.

*Photo: R. Farber.*

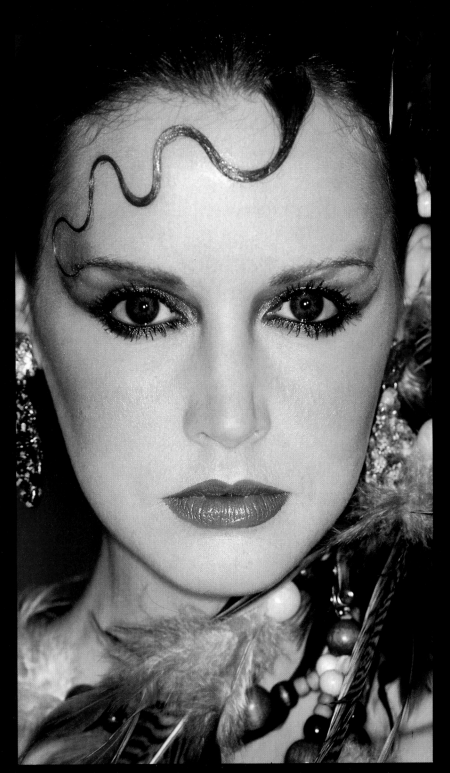

*Flash can catch slow subjects as well as those that move at high speed. In close-ups, flash provides maximum rendition of detail and color without disturbing the subject, except perhaps for 1/1000 sec. or less. Chapter 7 covers flash techniques in close-up and macro photography. Photo: C. M. Fitch*

There are many kinds of flash units you can use to achieve natural and special lighting effects. As you will see, the variety does not have to be bewildering—there are major similarities among all units, and often relatively minor differences within a particular class of unit. This book explains the differences in ways that will help you learn to distinguish significant features from those things that are essentially cosmetic features. That will make it easy for you to choose the equipment that is best for your own kind of photography.

There are also many ways of achieving the effects you want in your flash pictures. In fact, successful pictures depend far less on what kind of flash equipment you have than on how you use it. This book gives you the key to using flash in the most effective ways. It explains how flash units work. It shows you how to determine proper exposure in a great diversity of situations and applications, and with a great variety of subjects. And it shows you how to control flash to get whatever you want, from the most subtle and natural-looking results to the very wild and bizarre.

There are many special terms you may have encountered in hearing or reading about flash. They include fill-flash, bounce light, synchro-sun flash, direct flash, multi-flash, and many more. These are not obscure technical jargon, they refer to practical applications of flash. This

book shows you what each application is, and when and how to use it to the best effect. You will see and learn these things in terms of practical examples and clearly understandable explanations.

As you explore picture-making with the techniques described here, you will find that flash is easy to understand. Once you know a few basic principles, the actual techniques for using flash in most situations are quite simple. You also will find that when you use flash, your pictures are better than ever before. And that, of course, is the most important thing. That is why this book is for you.

*Repeat flashes with the shutter locked open caught these stages of movement. Existing light caused the "ghosting" to be recorded between flashes. An unlighted background avoided show-through exposure that would have weakened the colors in the main images. Photo: D. Garvey/West Stock, Inc.*

# 1

# The Basics of Flash

Without flash, many pictures you see would not be possible. In the home, household lighting is usually too dim for your color film. But flash lets you record special and ordinary events: baby's first steps, parties, family groups, and even—or especially—the family pet.

Professional photographers rely on flash, too. In the studio they use it to create effects not easily duplicated in nature: haloes of light in glamour shots and portraits, shadow effects, a twinkle in the eye, or a brilliant gleam on jewelry or glassware. Fashion photography would not be possible without flash: think of the sculpted look of a dress blown by the wind of a fan and frozen by a brief pulse of light. Many kinds of product and advertising photographs demand flash. You can't shoot ice cream or butter under the heat of floodlights; models and flowers wilt under heat; foods dry out; metal objects become too hot to touch for adjustments. Flash avoids those problems.

Sports photographers use flash to freeze the action of players as they compete. Even with fast films, lenses, and shutter speeds, the lighting conditions in many arenas make action-stopping photography nearly impossible without flash.

News photographers must always carry light with them because poor local lighting is no excuse for not getting the picture. They consider electronic flash units as essential as their cameras.

In industry, only flash can penetrate the workings of complex machinery, or light up an entire factory floor. As in scientific work, only stroboscopic flash units can make those sequence pictures that reveal high-speed, complex movements.

These are only some of the uses that make electronic flash the most useful light in photography. The basic information in this chapter will start you on the way to putting it to use for your own pictures.

*Flash is often an excellent way to visually isolate a subject. The f-stop required for proper exposure with the intense light of electronic flash will be too small for exposure of things receiving only ambient light in the scene, or those at the farthest extreme of the flash range; as a result, they will become a dramatic black. Photo: K. Bancroft.*

## Types of Portable Flash Units

There is an electronic flash unit for every need, and a need for different types of units. The problem at first is selecting one that is right for you. You must assess what it is you want to do, and then find the equipment that meets your needs.

Portable flash units all mount on a camera in one way or another. They range in size from those so tiny that they fit comfortably inside the pocket of a shirt, to units so large and heavy that the camera essentially mounts on them. Some units, especially the smallest, offer only manual operation—you must determine and make proper exposure settings. The majority of new units of all sizes provides automatic operation, explained later in this chapter.

**Shoe-Mount Flash.** By far the most popular units are mid-sized electronic flashes that mount in a camera's accessory shoe, located on top of the viewfinder of most 35mm SLRs. The units can be used for practically all kinds of photography, such as sports, general snapshooting, portraiture, and even close-up and macro work. In addition to automatic flash control, many offer the capability of directing their light up, down, or side-to-side.

Quite often these shoe-mount units have various accessories, such as diffusers to give the flash wide-angle coverage, light concentrators which narrow the beam to the area covered by various telephoto camera lenses, methods for reflecting the light off accessory "bounce boards," and filters for color correction or special effects. Many units operate on more than one power source, including a variety of battery sizes, and alternating current.

**Handle-Mount Flash.** A step up from shoe-mounting flash units in size and output are handle-mount or "potato masher" units, so-called from their overall malletlike shape. Once considered strictly professional equipment, they offer so much more flexibility and output

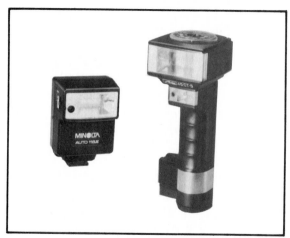

*Although small enough to sit atop a camera, some shoe-mount units (left) are quite powerful. Handle-mount units (right) provide much greater output and versatility.*

that many amateurs now prefer them. Handle-type units are too heavy for a camera's accessory shoe; instead, they mount along one side by means of a bracket which is usually screwed into the camera's tripod socket. Many arrangements permit the photographer to quickly remove the flash from the bracket to place it at the angle needed for a well-lighted, single-source flash shot. Handle-mount units now incorporate most of the convenience features of smaller units, including automatic output control, multiple power source options, and bounce and beam size accessories.

**Light Output.** The amount of light portable flash units produce is commonly indicated either by a guide number (GN) or by a measurement of effective (or beam) candle-power-seconds (ECPS; BCPS). A guide number is always related to a specific film speed; most manufacturers use ISO/ASA 100 as a reference rating when they list the specifications of their units. A guide number can be used with the flash-to-subject distance to determine the *f*-stop needed for proper exposure (see the next section). ECPS and BCPS ratings are interchangeable; they express actual output but cannot be used directly to determine exposure settings. Here are some corresponding ratings; the guide numbers are for use with flash-subject distances measured in feet:

| ECPS/BCPS of Unit | 350 | 700 | 1000 | 1400 | 2000 | 4000 | 8000 | 16000 | 32000 | 45000 |
|---|---|---|---|---|---|---|---|---|---|---|
| GN for ISO 100 film | 43 | 60 | 70 | 85 | 100 | 145 | 205 | 290 | 410 | 490 |
| Equivalent GN for ISO 25 film | | 20 | 30 | 35 | 43 | 50 | 70 | 100 | 145 | 205 | 245 |

**Technique Tip: Comparing Flash Output**

You can compare the output of various units by comparing either their guide numbers for the same film speed, or their ECPS/BCPS ratings; simply keep the following relationships in mind:

1. If the guide number for unit A is twice the guide number for unit B, A gives the equivalent of two *f*-stops more light than B. That is four times as much light.

Example: A GN = 80; B GN = 40. A's output is 4× (two stops) B's output.

2. If the ECPS/BCPS rating of unit A is twice the rating of unit B, A gives the equivalent of one *f*-stop more light than B. That is twice as much light.

Example: A = 2800 BCPS; B = 1400 BCPS. A's output is 2× (one stop) B's output.

## Fundamental Factors

There are two points about flash that are basic to using even very sophisticated units in almost any situation: synchronization and guide numbers. Getting these factors well in mind will help you master flash photography quickly.

**Synchronization.** The shutter must be fully open when electronic flash fires, otherwise the picture will be underexposed or partly blocked. The timing between shutter and flash is called synchronization, or sync; electronic flash must be connected for X-sync. The connecting terminal marked with an X or a lightning-bolt arrow on a camera is for electronic flash. A camera with a "hot" accessory shoe provides direct X-sync connection with a corresponding "hot foot" flash unit. (Terminals marked M, FP, or with a bulb symbol provide sync with various kinds of flashbulbs. See the data supplied with the bulbs, your camera instructions, and the last section of this chapter.)

The maximum X-sync shutter speed on cameras with focal-plane shutters (almost all 35mm SLRs) may be from 1/60 to 1/125 sec.; check your camera instructions. Usually the sync speed is marked in color or with the lightning-bolt symbol on the shutter control dial. You can use slower speeds, but not faster speeds because the shutter will not be fully open. Between-the-lens shutters synchronize with flash at all speeds.

*Typical camera flash features. (Top) PC-cord sockets on the front: X for electronic flash sync, FP for many flashbulbs. (Center) Electronic flash hot shoe on top of viewfinder; center contact connects flash unit to camera sync circuit. (Bottom) Sync speed (1/60) marked on dial in distinctive color. Some dials use X, colored dot, or arrow symbol.*

*If set at too fast a speed, a focal plane shutter will be only partly open when electronic flash fires. The result will be image cutoff.*

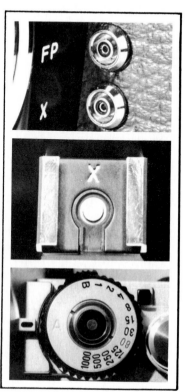

14

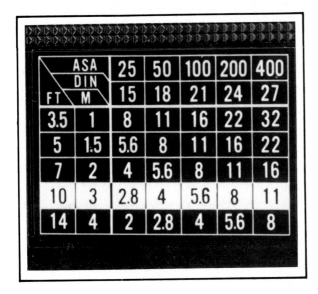

*Exposure guide chart on simple manual flash unit. To find lens f-stop, read down under appropriate ASA/DIN film speed and across from flash-subject distance. This unit performs best at highlighted distance of 10 feet (3 meters).*

| ASA / DIN — FT / M | | 25 / 15 | 50 / 18 | 100 / 21 | 200 / 24 | 400 / 27 |
|---|---|---|---|---|---|---|
| 3.5 | 1 | 8 | 11 | 16 | 22 | 32 |
| 5 | 1.5 | 5.6 | 8 | 11 | 16 | 22 |
| 7 | 2 | 4 | 5.6 | 8 | 11 | 16 |
| 10 | 3 | 2.8 | 4 | 5.6 | 8 | 11 |
| 14 | 4 | 2 | 2.8 | 4 | 5.6 | 8 |

**Guide Numbers.** Automatic flash units are amazingly versatile, but they can't cope with everything. Guide numbers are used to determine exposure with manual flash units and with automatic units used in manual operation. They are also very useful in figuring out multiple-flash set-ups.

Electronic flash is so brief that the proper sync shutter speed does not affect exposure; instead, the flash-subject distance, film speed, and lens f-stop determine exposure. The guide number (GN) relates these three factors; each unit has a different GN for different ISO/ASA film speeds. You use a guide number as follows:

1. Look up the GN of your flash for the film you are using; most units have a chart or dial with this information mounted on the side, top, or back.
2. Estimate or measure the flash-to-subject distance. If the flash is at the camera position, simply look at the lens distance scale after you have focused on the subject.
3. Divide the GN by the distance; the answer is the f-stop required for proper exposure. Set the lens to that stop.
   Example: GN = 80; distance = 10 feet.
   80 ÷ 10 = 8. Set lens at f/8.

If the answer is not an exact f-number, set the lens to the nearest f-stop, or between numbers if your lens has click-stop settings at the midway points.

Some units list guide numbers for feet and corresponding guide numbers for meters; be sure to measure the distance in the appropriate units for the guide number you are using.

For additional information about guide numbers, see the appendix.

Electric flash photography was first demonstrated in the 1850's. An open electric spark provided a brief burst of illumination to stop the movement of a rotating wheel. Modern electronic flash photography dates from the 1930's. The bulky units of those days are hardly the equal of what we now use in terms of size, flexibility, output, and convenience. Internally, however, flash units have changed little. They consist of a power source (either a.c. line voltage, or batteries), a method of storing the energy (capacitor circuits), a flash tube, and a trigger circuit. The flash tube is filled with gas, not wire or foil like a flashbulb; when jolted by a sudden input of high-voltage electricity, the gas releases energy in a high-intensity light burst lasting anywhere from 1/500 to 1/25000 sec., or less. The key to getting light is having sufficient power.

**Energy Sources.** Most portable electronic flash units use some sort of d.c. (battery) power supply. This can range from miniature AAA cells to high-voltage battery packs. Some can be recharged and are called secondary batteries; others (primary cells) are for one-time use only.

Primary cells for electronic flash fall into two basic categories: high voltage and low voltage. Low-voltage batteries have outputs from 1.5 to 9 volts. High-voltage packs have outputs between 225 volts and 510 volts. They have one strong advantage: High-voltage units can be made much simpler since in most cases they feed energy directly from the battery into the unit's storage capacitor. This is one reason recycling times are so fast with high-voltage batteries. Low-voltage batteries must have their energy "processed" before it can be used.

Low-voltage d.c. current entering the flash unit is first changed to low-voltage a.c. by an oscillator; that's what gives the characteristic "whine" you hear when you switch on a small electronic flash unit. This low-voltage a.c. is then fed to a transformer where it is stepped up to high-voltage a.c. Next the power goes to a rectifier which reconverts it to high-voltage d.c. for storage in the flash's capacitor.

Both types of batteries (high and low voltage) are available in primary and secondary forms. If you will use electronic flash only infrequently, select a unit that uses small, low-voltage primary batteries. If, however, you expect to use flash extensively, your best investment would be a flash unit that uses rechargeable (secondary) batteries. If the type of shooting you are doing requires taking lots of pictures at a time and you must have very fast recycling, high-voltage batteries (either primary or secondary) will give you the best service.

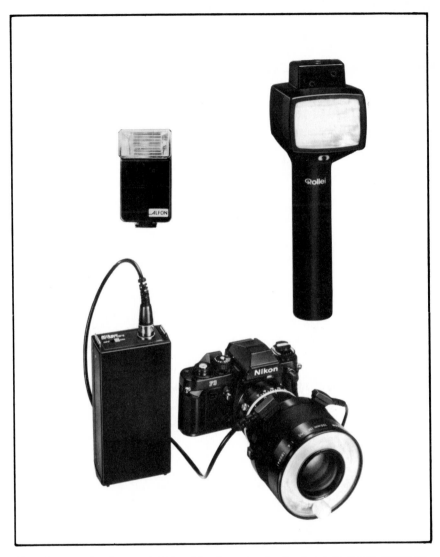

*Most shoe-mount units accept AAA or AA cells or ni-cad units of equivalent size. Almost all handle-mount units have rechargeable cell clusters which insert from the bottom. Special-purpose and high-power flash units have separate battery packs or power supplies. All types may also use a.c. power.*

There are portable flash units which use only line (a.c.) voltage, but many battery-powered units accept a.c. adapters. Most units recycle very rapidly on a.c. and operate very reliably. Since the power supply does not wear down, as batteries do, the number of flashes available is unlimited, but you are tied down by the power cord. A long extension cord takes care of that. A.c. operation is so economical and reliable that if you are going to shooting mostly indoors—look for a unit that uses both a.c. and battery.

## Flash Construction—Capacitors and Other Components

In order for a flash to fire, high voltage must be applied to the trigger circuit. This high voltage is stored in the unit's capacitor. The capacitor is usually cylindrical and is made up of many alternating layers of foil and electrolyte-impregnated paper rolled together. The capacitor and the batteries largely determine the size of a flash unit as well as its output. As output increases, significantly larger components, especially the capacitor, are required.

Capacitors store hundreds or thousands of volts of d.c. electricity; even in the smallest units there is enough high voltage to severely injure or kill you. *Never* open an electronic flash unit and touch any component with your hands or with tools. Internal repairs and adjustments are a job for a professional.

**Flashtubes and Triggering Circuits.** Flashtubes have many sizes and shapes—straight-line, coiled, circular—but they are all essentially the same. A glass or quartz tube containing xenon or another gas is sealed around an electrode at each end. When a pulse of very high voltage is applied via a triggering circuit, the gas in the tube ionizes. This permits the energy stored in the capacitor to arc across the distance between the electrodes, producing an intense flash of light.

**Color Output.** The color quality of the light from a flash tube is determined by the gas in the tube. The color temperature of an electronic flash usually is between 5500 and 6500 Kelvin, which is comparable to noon daylight. That is the light daylight-type color films are designed to match. The light from flash units is often rich in ultraviolet as well as visible wavelengths. The eye does not perceive the UV, but film can, producing overly bluish results. To avoid this, some flash tubes have a UV-absorptive coating; in other units the front lens is treated to block UV, or a gold-tone reflector is used behind the tube to "warm" the light enough to counteract the excess blue exposure.

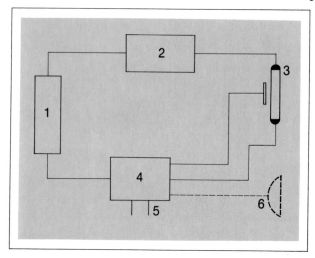

Basic electronic flash construction. (1) Battery or a.c. converter circuits. (2) Capacitor. (3) Flash tube. (4) Trigger circuit. (5) Connection to camera sync contacts. (6) Sensor (in automatic flash units).

## Technique Tip: Recycling and Exposure

Manufacturers put ready-light ignition points below 100% capacitor charge for a variety of reasons; one reason is to claim fast recycling times. Some units have multiple lights to show various percentages of full charge. Here are the approximate exposure effects of firing a unit at partial charge. Notice that the decrease in light output is greater than the decrease in voltage at each step downward.

| Percent Voltage in Capacitor | Percent Light Output | Exposure Error |
|---|---|---|
| 100% | 100% | 0 |
| 85% | 70% | − ½ stop |
| 70% | 50% | − 1 stop |
| 60% | 35% | − 1 ½ stops |
| 50% | 25% | − 2 stops |

**Triggering Circuit.** The trigger or firing circuit of an electronic flash unit is connected to the camera either by a PC connecting cord or by the camera's accessory hot shoe. When the shutter operates, contacts in the camera close this circuit and it in turn causes the tube to fire. The triggering circuit can also be closed by a remove slave unit —a switch and electric eye which respond to the burst of light from another flash unit—or by an "open flash" or "test" button on the unit itself.

**Ready Lights.** Once the flash has fired, it takes a certain amount of time for the capacitor to refill; this is called recycling. Flash units have small signal lamps called ready lights to let you know when the capacitor has enough power to fire the tube again. Units with more than one ready light indicate various stages of recharging; on many automatic flash units they also indicate over what distance range the flash can be used at each stage of recycling.

Some manufacturers set the "full ready" light to come on when the capacitor is at 85 percent of its rated capacity; others may make it as low as 70 or even 50 percent. Firing the flash at less than 100 percent charge can result in underexposure, as shown in the Technique Tip, because the unit output is reduced. It's a good idea to check a new unit with test exposures or readings with a flash meter to see how soon after the ready light comes on you actually get full light output.

## Flashbulbs, Cubes, Strips, and Bars

Although they are not frequently used with 35mm cameras, various kinds of flashbulbs are a common feature with some cameras, especially those using 110, 126, and instant-picture films. Flashbulbs are available as individual small bulbs which plug or screw into a reflector socket, or in a more convenient form: several bulbs mounted in a cube, or on a strip or bar of support material. Multiple-bulb devices eliminate the need to change bulbs after every shot and are easier to carry.

All flashbulbs are constructed in a similar manner. They have a base, a means of ignition (called a primer), and a metallic filling, usually zirconium or aluminum wire or foil, which burns to emit light. They are surrounded with a glass envelope which is coated with lacquer so it will not break when fired. Most bulbs have a blue-tinted lacquer so their light will match the color balance of daylight-type color film. Clear (untinted) bulbs should be used only with tungsten-type color film or black-and-white film.

Individual flashbulbs must be mounted in a reflector; the size, shape, and reflective finish of the reflector affect the flash efficiency. FlipFlash strip units, Flashbars, and flashcubes have built-in reflectors. FlipFlash units are most often used for 110-size cameras. They are neat, tall packages of eight or ten bulbs arranged in two rows. They do

*The area of even illumination with flashbulbs and small flash units is limited in depth. For best results, keep all subjects as much the same distance from the flash source as possible, otherwise some may be too bright or too dark in the final picture. Photo: J. Alexander.*

not need batteries, but are fired by a mechanically produced pulse from the camera. The bulbs in one row fire in succession, then the unit is turned end-for-end to use the remaining bulbs.

The bulbs are powerful for their size, but their use is limited by the maximum aperture of most of the lenses they are used with; commonly their distance range is 1.2 to 2.7 meters (4 to 9 feet) with an $f/8$ lens.

Flashbars are similar to FlipFlash units, but are powered by a battery in the camera. With some instant-print cameras they can be used over a surprisingly broad range—from 27 cm to 6 meters (10.5 inches to 20 feet).

Flashcubes are four small bulbs mounted in a four-sided reflector cube. After each shot the cube rotates to present a fresh bulb for use. The range of standard cubes is close to that of the FlipFlash, but high-power cubes are twice as bright. Standard cubes require external battery power; X-cubes (Magicubes) do not.

Although they offer plenty of light for the cameras with which they are normally used, these various kinds of flashbulbs have limited versatility. They are being replaced in even the simplest cameras by tiny built-in electronic flash units which are no more versatile, but which eliminate the need to carry or replace anything extra.

*Flashbulbs are rapidly disappearing from use because even pocket-size cameras now have built-in automatic electronic flash along with other sophisticated features such as automatic focusing.*

# 2

# Automatic Electronic Flash

The light on a subject from a flash unit gets stronger or weaker as the distance between them gets smaller or larger. This means a different exposure is required for each different flash-subject distance. With manual flash the duration of the light burst is always the same, so you have to change the $f$-stop with each distance change.

Automatic flash units eliminate the need to change $f$-stops; they let you use the same $f$-stop at many different distances. In addition, they can conserve power so you get more flashes from each set of batteries or charging period.

Auto-flash units work by changing the duration of the flash. The light is equally bright each time, but it is on for a long or a short time according to the subject distance. The key component in auto-flash operation is a light-sensitive cell connected to the capacitor-flash tube circuit. The effective reaction level of this sensor can be adjusted for the speed of the film in use. When the flash fires, the sensor receives light reflected by the subject and cuts off the flash tube when the reaction level is reached. If the subject is very close, enough light is reflected for the sensor to act almost immediately. If the subject is more distant, it takes longer for the light to be reflected, so the flash remains on longer. In this way a single $f$-stop can be used for subjects in a distance range whose limits are determined by the maximum and minimum possible durations of the flash.

In the first auto-flash units, cutting off the flash tube diverted the unused energy to a non-light-producing quench or "dump" tube in the unit. The capacitor emptied completely every time and so had to drain full power and take the full time to recycle after each flash. Modern automatic flash units use thyristor control circuits that cut off the flash tube but do not empty the capacitor. A partially-emptied capacitor uses less power to recharge fully, and does it in a shorter time. Thus, thyristor flash units conserve power and provide faster recycling with almost any subject not at the far limit of the distance range.

*Automatic flash units provide excellent exposure control in a great variety of situations. When a unit is placed away from the camera, as for this kind of picture, the control sensor should be located at the lens position to measure the light at the actual exposure distance. Notice how effectively a colored background card has been used to set off the subject. Photo: C. M. Fitch.*

## Auto-Flash Working Distances and *f*-Stops

All flash units have a maximum working distance; the light simply will not carry beyond that point with enough intensity for proper exposure even at the maximum lens opening. There is also a minimum working distance with auto-flash units. If the subject is closer, the sensor cannot turn off the flash fast enough to prevent overexposure, even at the smallest *f*-stop the unit permits you to use.

**Distance Ranges.** The working distance limits are indicated on a flash unit usually either by a dial or by a series of bar scales. Various kinds of indicators are explained in the accompanying illustrations. Your unit may not have exactly the same thing, but the indicators and their methods of use are quite similar among the major kinds of units. Compare these examples with the instructions for your own unit; that should make it easy to understand the principles of using auto-flash.

Many small, low-power units provide automatic operation over the entire distance range at a single *f*-stop; however, this has significant limitations. In order for the distance range to remain the same, a different *f*-stop is required for each different film speed. When you set the unit for a particular film speed you can use only the corresponding *f*-stop, no other, for auto-flash control. As a result you have no way to vary depth of field (the near-far sharpness zone) if you would like to. In addition, the maximum distance may be quite limited—as little as 3.75 meters (12 feet), while more power and more versatile units may be effective at better than 15.25 meters (50 feet) from the subject.

*Automatic flash units have distance scales to show the limits of the exposure range at various f-stops. The aperture scale on this unit shifts left and right to align a dot at 1/8 above the proper film speed. Then the colored bars show the exposure ranges in relation to the distance scales above.*

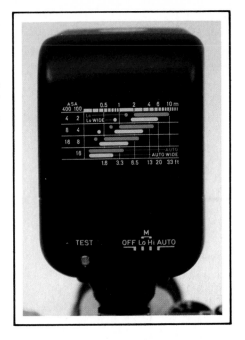

*This auto-flash unit offers a choice or three f-stops with a 400 speed film or four f-stops with a 100 speed film. Orange bars indicate the normal auto exposure range for each stop; white bars indicate the ranges when a wide-angle flash adapter is used. The colored dots indicate flash-subject distances for manual exposure at low power; the distances for high power manual operation are the same as the maximum auto exposure distances.*

**Multiple *F*-stops.** Medium- and high-output auto-flash units produce so much light that a single *f*-stop cannot cover exposures over the entire distance range. Such units offer you a choice of two to five or six stops, depending on their power and design. The actual *f*-numbers change according to what film speed you set the unit for, but the distance ranges remain the same and they overlap. Typically, the smallest *f*-stop covers at least the nearest two-thirds of the entire distance range, and the largest *f*-stop covers the farthest two-thirds, or more. If intermediate *f*-stops can also be used, they cover overlapping ranges of similar length within the two extremes. The illustrations will help make this clear.

You can use any of the *f*-stops indicated on the unit (after you set it for the film speed) that includes the distance your subject is located at, measured from the flash unit position. This gives you some degree of depth of field control; you can use the largest suitable *f*-stop for selective focus, or the smallest *f*-stop for increased near-far sharpness.

For clarity and easy use, most manufacturers color-code their multiple *f*-stop indications. All you have to do is identify the color of the stop you want to use, set the lens to that stop, and switch the flash unit sensitivity control to the same color setting. That adjusts the response of the sensor for precise automatic control with that particular aperture. Again, the illustrations will help make this clear.

## Auto-Flash Sensors

The light-sensitive cell—the sensor—and its associated circuits are the metering system of an automatic electronic flash unit. Like the cell of a reflected-light meter, the flash sensor must be aimed to read the main subject accurately.

The sensor in most units is located just below the flash tube lens. When the flash is at the camera and aimed directly at the subject, the sensor reads essentially the same light that will strike the film and thus can give accurate exposure control. But if the flash is aimed away from the subject toward a reflecting surface (bounce flash), or if the unit is moved away from the camera to light the subject from an angle, the sensor may not see the same light that reaches the lens. For accurate exposure control the sensor must be located at the camera position and aimed at the subject, no matter where the flash is located and aimed.

In flash units with heads that tilt or swivel, the sensor usually is located in a lower portion of the body so its direction does not change as the head is moved. But that does not solve the problem of off-camera flash positions. By far the greatest versatility is provided by units which accept a remote sensor.

**Sensor Coverage.** Like a light meter, a flash sensor has a certain area of coverage determined by its angle of acceptance. The smaller this angle, the narrower the field the sensor covers and the more discriminating the exposure control will be.

Flash units with narrow acceptance angles put increased "metering" emphasis on the center of the scene. If you have a dark subject in the center with light areas around it, there is a better chance of getting a well-exposed image of the subject with a narrow-angle sensor. One with a broader angle would see too much light from the more reflective surroundings and would cut off the flash too soon.

This unit's sensor is in the module below the trademark. It remains aimed at the subject even when the head is tilted upward for indirect or bounce flash. The sensor module unplugs so it can stay at the camera position when the unit is placed elsewhere; connector pins at the bottom are for a remote flash-sensor extension cord.

**Thinking for Sensors.** Sensors are like reflected-light meters in another way: They do not know what they are looking at, they assume everything is of average brightness or reflectance, and they produce only average exposures. If you have a light-colored subject in light surroundings—a high-key shot, for example—you must do the thinking and open the lens one-half to one full $f$-stop because the sensor will be cutting off the flash quickly in response to the great amount of reflected light. The opposite is also true. If the subject is dark, and in dark surroundings, you must close the lens one-half to one full $f$-stop because the sensor will be prolonging the flash duration in response to the reduced amount of reflected light.

**Remote Sensors.** A remote sensor is simply a separate light-sensitive cell which connects to the flash unit by means of an extension cord. When plugged in, it overrides the sensor built into the unit body. The remote sensor is kept at the camera position, aimed at the subject; many are designed to mount in a camera accessory shoe. The flash unit can be moved as far as the extension cord will allow, and aimed in any direction. So long as it does not shine directly onto the face of the sensor, its flash duration will be determined by the amount of light actually reaching the camera, and that will provide the most accurate exposure control.

## Flash Reciprocity Effect

The reciprocity effect is the failure of film to build up an image of normal strength during an exposure that is "correct" according to meter readings or usual methods of calculation. This effect commonly occurs during time exposures with very weak light. It also occurs during very brief exposures with high-intensity light, and that is what concerns us in flash photography.

Before the advent of automatic electronic flash units, flash reciprocity effect was seldom a problem; most units produced light for a long enough time to avoid the effect. However, when a light-colored subject is close to the camera, an auto-flash unit may produce a burst only 1/10,000 sec. long, or even a burst that lasts only 1/50,000 or 1/100,000 sec.

You can visualize the reciprocity effect this way: Think of a film emulsion as containing many pockets. Each pocket is a light receptor and can hold a certain amount of light. Think of light as a series of golf balls all strung together, traveling in a waveform. If you throw the balls at the pockets too fast and in too large a quantity, two things will happen. One, the receptors (pockets) will not be able to accept all the light (the balls) thrown at them. Two, if the balls are thrown too hard (high intensity), they will hit the pockets and bounce right out again.

In order to compensate for the light that hits too fast and too hard, you can do two things: adjust the lens aperture to let more light hit the film to make up for "the ones that got away," and increase development to make full use of the amount that doesn't get away.

In color pictures, especially those on slide film, the reciprocity effect is visible as slight underexposure (dark images) and unusual color shifts. Many films require no compensation for exposures as brief as 1/10,000 sec. For example, Eastman Kodak Co. data indicate that only Ektachrome 64, 160, and 200 films require compensation—a half-stop more exposure—at that flash speed; other Kodak color films do not require compensation. At shorter flash durations additional exposure and corrective filtration may be required. Contact the film manufacturer for specific recommendations.

Reciprocity effect in black-and-white produces reduced contrast with weak highlights and overemphasized middle tones. Kodak makes the following general recommendations for their black-and-white films; similar compensation can be used with the other films.

| Reciprocity Correction for B/W Films | | | |
|---|---|---|---|
| Flash Duration | Open Lens | and | Increase Development |
| 1/1000 sec. | — | | 10% |
| 1/10,000 sec. | ½ stop | | 15% |
| 1/100,000 sec. | 1 stop | | 20% |

*Flash reciprocity is not a common problem, although it may occur with auto-flash units used very close to a subject. Proper compensation, if necessary, will insure full, rich colors in the image. Photo: C.M. Fitch.*

29

## Dedicated Flash

Dedicated flash units are specially designed to couple with the exposure control circuits of a particular camera model or models in order to provide extremely sophisticated automatic control. Most major camera manufacturers offer dedicated flash units for their advanced 35mm cameras, and many independent manufacturers now offer dedicated flash units which can be connected to a variety of cameras by means of adapter modules.

A typical dedicated flash unit connects through the hot shoe of a camera, either directly by means of contacts in the foot of the flash, or by an adapter foot. The camera signals the flash unit the speed of the film in use and the $f$-stop setting of the lens. When ready to fire, the flash unit activates a ready indicator in the camera viewfinder and automatically sets the shutter to the proper synchronization speed, no matter what speed is set on the control dial. When the exposure is made, the unit sensor controls flash duration in the usual way for automatic control. During recycle time the viewfinder indicator goes out, and the flash unit releases shutter control to the camera at the original speed setting. If there was not enough flash for the distance and $f$-stop conditions, the unit activates an "insufficient exposure" indicator in the camera viewfinder after the shot has been made.

Some dedicated units can be used off camera; the remote sensor module which mounts in the hot shoe provides all the interconnections. Most dedicated flash units offer manual operation in addition to their automatic modes, and most can be used with some degree of auto control with other cameras, using a standard PC cord for connection. In those cases, you must make flash and camera settings as with ordinary auto-flash units.

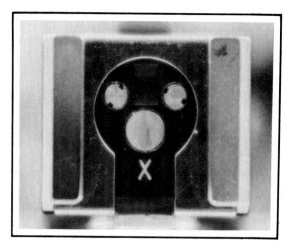

A camera hot shoe with multiple contacts can accept non-dedicated as well as appropriate dedicated flash units. The large center contact provides the sync connection for all units. The smaller contacts provide meter, shutter, lens, and other connections with a dedicated unit.

A highly versatile camera and dedicated flash combination like this provides the greatest degree of handling ease and exposure accuracy in automatic flash photography.

A further degree of control is offered by cameras which have behind-the-lens meters with flash-metering capability. In this case the camera meter takes over the control function of the unit's sensor; it reads the light at the film plane and controls flash duration accordingly. This means you need no extra calculations for filters, close-up extensions, and other special conditions which reduce the amount of light passing through the lens.

# 3

# Direct Single-Flash Techniques

The greatest number of flash pictures are taken with just a single flash unit. Although professional photographers may use two or more units for portraits or pictures of products, the number of pictures that require such complex set-ups is really quite small. In fact, many effects of multiple-flash photography are easily duplicated with a single unit used in combination with reflectors and various other light control devices.

Certainly amateur photographers, from beginning snapshooters to those with advanced skills and creative ambitions, seldom use more than one flash unit. As you will see, that is not a restriction..A single flash unit is a highly versatile lighting instrument, one capable of producing top-quality pictures of any kind of subject when used with knowledge and skill. In most situations single flash is more versatile than a continuous light source such as a floodlight or spotlight. The flash illumination can be controlled and changed to a greater degree, there is more light from a far more easily handled unit, and there may well be automatic control of the light. No continuous light source offers automatic control, and no ordinary continuous lighting instrument operates on a variety of battery power supplies, freeing you from having to stay within range of an a.c. outlet.

A single flash cannot guarantee excellent results. Some of the worst pictures in the world were taken with one flash unit badly used —aimed directly at the subject, close-up, from the camera position. The soot-and-whitewash harshness we associate with bad newspaper pictures is usually the result of misused single flash. But these disasters are not inevitable. There are ways to get full-range results with a single flash that look natural. It is possible to get soft, delicate light in a picture using a single unit. It is possible to achieve high-key and low-key effects, to get expressive shadows, or to get dramatic high contrast that does not look like inept overexposure and underexposure in the same picture. In this chapter you will see how to avoid the mistakes and how to achieve the positive effects possible with single flash.

*Only direct flash can reach out to illuminate a subject like this without disturbing it, and only direct flash can give so much richness and detail in dark-colored areas of the subject. Photo: C. Child.*

## Direct Flash

You get the greatest amount of light on the subject by aiming your flash directly at it; you also get the greatest number of problems. There is no denying the convenience of on-camera direct flash: Wherever you move, the light moves with you, without trailing cords, light stands, or other excess equipment. And, wherever you point your lens, the light is pointed the same way. Most of the problems with direct flash occur when it is used at the camera position, close to the lens.

**Flat Light.** Head-on light illuminates everything evenly, erasing the variations that reveal contours and volume. You will see the overall outline of the subject, but little of its own variations of form. Move the flash away from the lens, to one side, and up, if possible. This will create shadows and highlights that model the subject and give it a three-dimensional appearance.

*Direct flash is the first choice for capturing action at its peak. A dark, distant background avoids shadow problems. Photo: J. Peppler.*

Often you can aim direct flash so that shadows fall on unimportant things in the scene or are concealed by the main subject. Notice also how the falloff in light intensity helps subdue a visually busy background. Photo: R. Mickelson.

**Background Shadows.** On-camera flash throws large, dark shadows of the subject and other objects in the scene on a close background; the result is heavy, confusing, and unpleasant. There are three basic solutions:

1. Choose a very dark background so that the shadow merges with it and is unnoticeable. This is not always possible, or appropriate.
2. Move the subject well forward of the background so that the shadow spreads widely and loses intensity. This will also cause the background to look darker, because of the light fall-off, so the shadow will blend with it.
3. Position the flash up and to one side so that shadows fall on the floor, behind and beside the subject. This is often the best and easiest solution if you have a sync cord long enough to let you hold the flash up at arm's length; it's standard procedure with news photographers.

**Red Eye.** When the flash is aimed along the lens axis from a position very close to the lens, it may be reflected off the interior surface of a subject's eyes. In color pictures this makes the pupils appear red instead of black; in black-and-white pictures they have a "blanked-out" white or light gray appearance. This most often occurs when the existing light level is low, causing the subject's pupils to open wide. To avoid red eye, raise the existing light level, or ask the subject to look a bit away from the lens (not always suitable), or—the surest solution—raise the flash at least six inches above the lens.

## More Problems and Solutions

**Background Glare.** When the flash and the lens are aimed head-on to a reflective background, you will record a glaring hot spot from the direct reflection of the flash. Finished wood panels, mirrors, glass in picture frames, glossy painted cabinets or walls, smooth plastic and stone, and similar surfaces can cause this problem. The solution is simple: Change position slightly to aim at the background from an angle so that the reflection is not directed toward the lens.

**Misexposure in Depth.** Light loses intensity as it gets farther from the source because it is spreading out over an increasing area. If your auto-flash sensor responds to nearby objects, it will cut off the flash quickly and more distant objects will be underexposed (too dark). If a narrow-angle sensor is aimed at distant objects, nearby ones will be overexposed (too light). If you are using manual control for proper middle-distance exposure, distant objects will be too dark and nearby objects too light. All this occurs with subjects which have significant depth; for example, an object twice as far away as another object receives *two* f-stops less light! To avoid this, keep the farthest important object *less* than one-and-a-half times the distance of the nearest important object—for example, a range of less than 1.8 to 2.75 meters (6 to 9 feet), or 3.7 to 5.5 meters (12 to 18 feet).

A better solution is to reflect the flash off a nearby surface so that it covers a large area more evenly; see the chapter on bounce flash.

*Glare is inevitable if you use flash head-on to a reflective background, no matter what its color. Shoot from an angle instead.*

*In manual flash operation, a foreground subject will be overexposed when you use an f-stop for proper exposure of a more distant subject. With automatic flash, the foreground subject usually will be properly exposed, the distant subject too dark (underexposed). Photo: H. Hankin.*

To reveal texture or detail such as relief carving on a surface, use direct flash at a low angle so that the light skims across the subject. Head-on flash would light the recessed portions equally with the surface, making them less distinct. Photo: A. Moldvay.

**Harsh Light.** Direct flash causes very bright highlights and dark, specific shadows; to soften this contrast, soften the light by diffusing it or spreading it out. Use a wide-angle adapter over the lens of the flash unit, or a diffusion accessory. Improvise a diffuser by placing one or more layers of white handkerchief, facial tissue, or paper napkin directly in front of the flash head. Each layer will reduce the light intensity about one $f$-stop. An auto-flash sensor will adjust for this, but only if the diffusing material does *not* cover the sensor. In manual operation you will have to open the lens an appropriate number of $f$-stops.

For the greatest softening, bounce the light from a reflective surface instead of aiming it directly at the subject.

To reduce glare and the intensity of direct flash, use an accessory diffuser on the flash unit, or cover the head with one or more layers of white cloth or tissue. Pull the material smooth across the face of the flash.

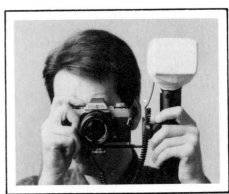

## Direct Flash Set-Ups—Shadow Effects

Most flash set-ups are equally suitable for portraits and other pictures of people and for pictures of objects. In order to see the effects of various set-ups clearly, most are illustrated in the following pages with a single subject; a face or figure is used because people are by far the most common photographic subject. The effects will be the same with multiple subjects, and the picture will be visually more complex. Your major concern with more than one subject must be to make sure that the shadow of one does not obscure another.

**Shadows.** To produce dramatic shadow effects and high-contrast images, aim the flash at the subject and do not allow any reflected light (fill light) to hit the subject from a different angle. If you want the shape of background shadows to be an important part of the picture, keep the subject close to an appropriate background. Otherwise, avoid light-colored backgrounds so that reflected flash will not lighten subject shadows or reduce contrast.

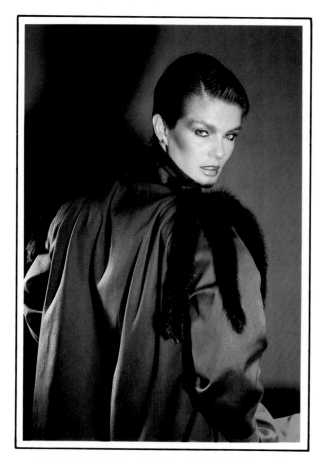

A deliberate shadow effect for visual interest. With the model close to the background, the main light was placed low and to the right to separate the shadow from the subject. The sidelight on the cloak was carefully aimed from the left to not hit the background and weaken the shadow. Photo: V. Podesser.

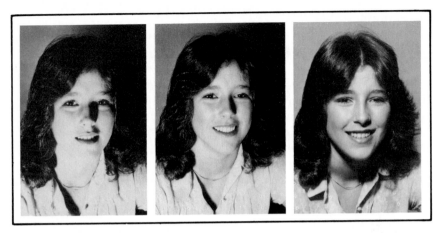

*Single-flash effects, flash just to left of camera. (Left) Low. (Center) At eye-level. (Right) High.*

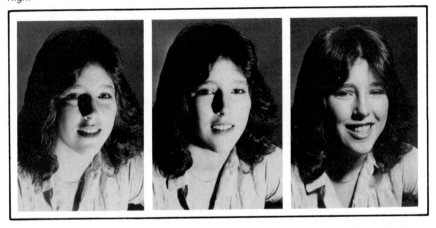

*Single flash 45 degrees to right of camera. (Left) Low. (Center) At eye-level. (Right) High.*

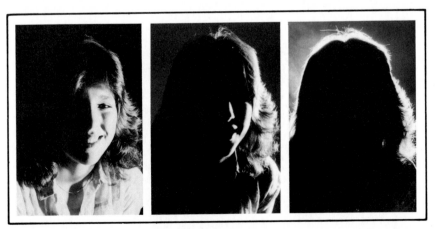

*Single flash head-high (eye level). (Left) 90 degrees to right. (Center) 135 degrees to right. (Right) Directly behind subject. Photos: B. Bennett.*

## Direct Flash Set-Ups—Full Light

Flash units produce a beam of light that is broader than the central subject of a picture. To get a fully-lighted effect, or to lighten shadows for natural looking visibility, you can use a reflector to pick up some of the light spilling past the subject and direct it where you want it. This is the secret of excellent lighting with a single direct flash.

You can use any white or silver material for a reflector; colored materials are generally unsuitable because they will cast their own colors on part of the subject. A matte surface reflector avoids hot spots and glare from a direct reflection of the flash head. For a large area, a hanging white sheet or a sheet of plywood painted white is suitable. For smaller areas, sheets of white poster board or mounting board are lightweight and easy to position. You can tie or tape them to tripods, lightstands, coat racks, music stands, straight-back chairs, or many other improvised supports. They can be held in a curved shape with a piece of string or tape to control and concentrate reflected light quite precisely.

Professional photographers are well aware of the versatility of flash-plus-reflector lighting. One set-up in particular is used more widely than any other; you'll see it again and agin in food and small product advertising photographs, and in glamour and cosmetic-ad close-ups. The direct flash unit is above and behind the subject, aimed forward to provide bright backlighting that outlines edges crisply. Soft, diffuse frontlighting, perfect for the limited contrast range of color film, comes from a reflector which catches the spilled flash and bounces it back onto the portions of the subject facing the camera.

The illustrations on these and the following pages show you how to get the most lighting variety with the least amount of equipment: a flash unit and one or two reflectors.

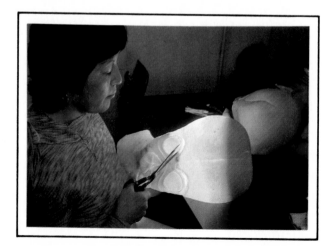

A single flash unit placed directly behind the mask for a transilluminated glow also provided warm, indirect light on the woman. Photo: A. Moldvay.

Classic product lighting: Direct flash behind and above, a bit to the left; a white reflector in front, low and slightly to the right. Notice how light reflected by the subject itself also adds to the effect. Photo: T. Tracy.

To use a single flash unit for outline shadow emphasis, keep the subject close to the background so the shadow will be the same size and largely concealed. Aim the flash through diffusing material to soften the shadow edges.

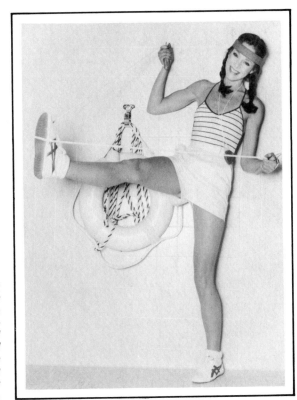

# Direct Flash and Reflector Set-Ups

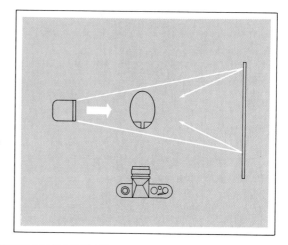

Place flash head-high, 90 degrees to one side; use a white or silvered reflector directly opposite. Move the reflector closer to lighten shadows more. Subject can face slightly toward flash if desired.

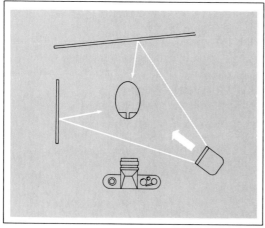

Use the flash 45 degrees to one side and 45 degrees above eye-level. Put a reflector directly on the opposite side of the subject at head height. A reflective or light-colored background is good with dark-toned subjects.

Use a silvered reflector near the subject and close to the camera. Place the flash directly behind subject at head height, or lower for a halo effect; a dark background will emphasize the halo.

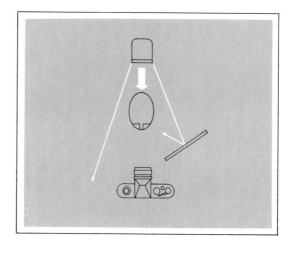

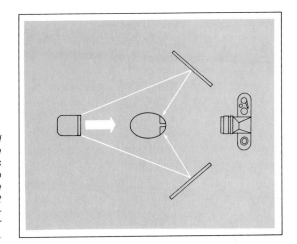

*Use flash directly behind or above subject from the rear, with front reflectors at eye-level 45 degrees to each side. Vary the reflector distances for soft modeling. This is an excellent set-up for glamour portraits.*

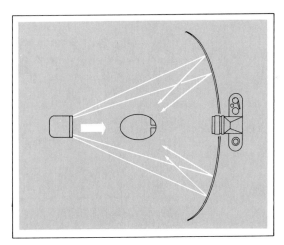

*A variation of the above set-up uses a large curved reflector of white paper, or poster boards taped together, with a hole for the camera lens. The diffuse, even front light is fine for shiny or polished surfaces.*

*Side view: Flash directly overhead, like noon sunlight. Put a reflector below to throw light upward into the pronounced shadows. Without the reflector, the direct light effect is quite harsh.*

## Flash Fill

Flash is not only for use inside, it can be a valuable supplement to sunlight outdoors. Electronic flash is especially suited for this because it closely matches the color temperature of sunlight from mid-morning to mid-afternoon, so there is seldom a need for filtration for color matching.

Flash may be used as the main light source outdoors, especially in heavily shaded locations or under extreme overcast. In those cases, the techniques are simply those of direct flash, as already explained in this chapter. A much more subtle, and widespread, use of flash is to combine it as a fill light with sunlight as the main or key light.

Flash fill with sunlight (an older term, synchro-sun photography, means the same thing) has two major advantages. It allows you to turn the subject far enough away from the sun to eliminate squinting and other reactions to the glare of direct sunlight. It also lets you fill in, or lighten, the dark shadows direct sun creates so that color and detail is fully visible and so that the entire subject is well within the contrast or exposure range of the film you are using. This is especially important with color film, which has a much more limited range than black-and-white film.

*In open shade, "fill-in" flash actually becomes the strongest light on the subject, as shown by the shadow of the stump on the ground. The problem is to light the subject fully without losing detail in the background from too little exposure, or letting the background get distractingly bright from too much exposure. Photo: K. Bancroft.*

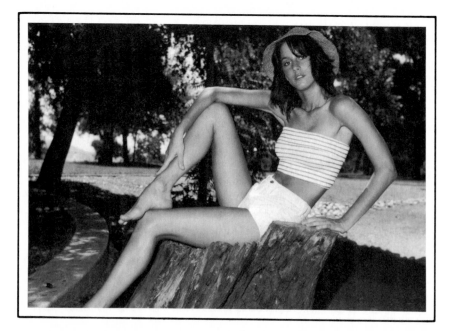

**Flash-to-Sun Ratios.** Flash fill is most effective when it is not noticeable; that is, when it is weaker than the sunlight. If it is stronger, the picture looks artificially lighted because the main light on the subject (the flash) comes from a different direction than the main light on the surroundings. When the flash is equal to the sunlight, the effect is much the same as head-on direct flash—shadows and modeling are eliminated and the subject looks two-dimensional.

With color slide film, the most useful balance is to have the sunlight one *f*-stop (two times) brighter than the fill light from the flash. This is actually a 3:1 lighting ratio; see the Technique Tip on page 67. A ratio with the sunlight two *f*-stops (four times) brighter than the flash fill—a 5:1 lighting ratio—is a bit much for slide film with most subjects, but it can give good results with color and black-and-white negative films. A three *f*-stop difference (9:1 ratio) is the maximum useful limit in black-and-white with most subjects.

*When the subject is in a sunlighted area, it is easiest to compute flash fill if you use the sun as a direct backlight, as here. Photo: K. Bancroft.*

## Setting-Up Flash Fill

It is easy to establish any lighting ratio you want in a sunlight-plus-flash situation with either an automatic flash unit or a manual-only unit.

**Fill with automatic units.** Take a normal meter reading to see what exposure is required just for the sunlight. You will have to use the sync shutter speed, so see what $f$-stop is required at that speed; for example, $f/11$ at 1/60 sec. (sync speed).

Look at your auto flash unit to see what $f$-stop you can use for auto operation (if your unit offers more than one) that is closest to the sunlight exposure $f$-stop. If it is the same, *do not* use that setting; the flash will equal the sunlight and you will have flat lighting. Instead, set your unit for one or two $f$-stops *wider*—$f/8$ or $f/5.6$, as compared to $f/11$. Assume that you choose $f/8$.

Now take the picture, using the settings required for proper sunlight exposure: $f/11$, 1/60. The flash sensor does not know the lens is set for $f/11$; the sensor is set for $f/8$, so it cuts off the flash when that amount of light has been received, sooner than if it had been set for $f/11$. In this way the flash-illuminated portions of the subject receive one stop less exposure than the sunlighted portions, and you have the desired key-to-fill lighting ratio.

This procedure will work with any automatic flash units except dedicated units that sense the actual $f$-stop setting of the lens, or that are controlled by in-camera flash metering. You can use such units for flash fill by setting them for manual operation. In addition, the flash instructions may give you special procedures for flash fill in automatic operation; check for this carefully.

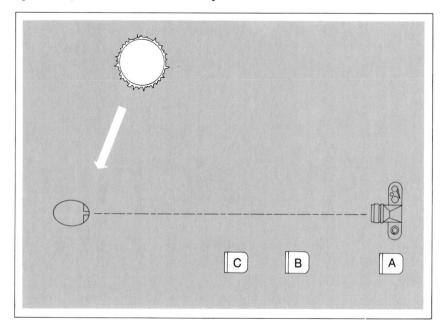

**Flash fill with manual units.** Whether you use an automatic flash unit on the manual setting, or a manual-only unit, the procedure for establishing flash fill is the same:

1. Take a meter reading to find the sunlight exposure at the sync speed; say $f/11$ at 1/60 sec. This is the actual exposure setting you will use on the camera.
2. Determine the required flash-to-subject distance for the lighting ratio you want. For a 3:1 ratio the fill must be one stop less bright than the sunlight, so find the distance that would be required for one $f$-stop larger ($f/8$) than the stop you will actually use. You can get this distance from the flash calculator dial, if it is set for the film speed you are using. Or, you can get the distance by dividing that $f$-number into the guide number of the flash unit. For example, if the unit GN for your film is 56, you need a flash-to-subject distance of 7 feet (56 ÷ $f/8$ = 7).
3. Place the flash at that distance from the subject and take the picture, using the settings required for proper sunlight exposure.

If you have a zoom lens, you can keep the flash on the camera and achieve the framing you want with the camera at the required flash-to-subject distance. Otherwise, you will need an extension sync cord so you can move the flash to the required distance while you keep the camera in the position your picture composition calls for.

If your flash unit has a variable output feature (½, ¼, ⅛ power, etc.) for manual operation, it's easy to get flash fill ratios without any $f$-stop calculations. Simply put the flash at the distance called for by the $f$-stop you have set on the lens, and then select half-power for a 3:1 ratio, or quarter-power for a 5:1 ratio.

Even without a variable output selector, you can use this method. Place layers of white handkerchief or tissue over the flash head; each layer reduces the light by one $f$-stop. Or, use neutral density filters (available at photographic stores) in front of the flash head; each density increase of 0.3 reduces the light by one $f$-stop.

*Basic flash fill. Use the sun as an angled front light or a sidelight; keep the flash close to the opposite side of the camera-subject axis. Set the lens for proper sunlight exposure at the sync shutter speed. With automatic flash at the camera (A), set the unit for one or two f-stops wider than the lens aperture. With manual flash, move the unit to the distance (B or C) that would be required if the lens were set one or two stops wider. Use the distance for a one-stop difference for a 3:1 ratio, or the distance for a two-stop difference for a 5:1 ratio. See the text for other ways to adjust manual flash fill.*

# 4

# Bounce Flash

Although direct flash provides the maximum amount of light on a subject, many experienced photographers prefer to sacrifice some quantity in order to obtain a more pleasing quality of light. They do this by aiming the flash unit away from the subject, toward a reflective surface which in turn directs the light to the subject. This technique is known as using bounce flash.

Reflected or bounce light is softer, more diffuse than direct light; it creates lighter shadows with indistinct, "feathered" edges, and less contrast. These techniques make it especially suitable for color photography. It is the widely preferred kind of light for glamour photographs, portraits that flatter or romanticize the subject, highly reflective objects such as glassware, jewelry, and silverware, and many other subjects.

Bounce light covers a larger area more uniformly than direct light does. That makes it the best choice for subjects in depth, and for allowing subject movement without worrying about exposure adjustment. These factors are important in the studio, and perhaps even more important in the spontaneous, changing situations news and sports photographers cover.

Bounce flash originated in the studio, where very high powered electronic flash units and a variety of reflectors are common equipment. Today, the high power and efficiency of even quite small portable flash units make it easy to use bounce flash anywhere you care to work. Many units have operating features and accessories especially designed for bounce flash lighting. Whether you have an automatic or a manual flash unit, you can take advantage of this approach to subject lighting in almost any situation. Bounce flash increases the versatility of single-flash lighting to such a great degree that many photographers consider it their most useful controlled lighting technique.

*Only bounce light provides the soft, glowing illumination that flatters the subject in a close-up like this. Direct flash provides plenty of light intensity, but the way in which it reveals every pore and minute skin variation is too harsh for glamour photography; the caressing quality of bounce light is far more appropriate. Photo: R. Farber.*

## Built-in Bounce Features and Accessories

Because more photographers use flash than ever before, and because they recognize the advantages of bounce flash, an increasing number of flash units have built-in features that make bounce lighting easy. Many units also accept accessories specially designed for bounce work.

**Movable Heads.** The ability to tilt and perhaps swivel the flash head allows you to keep the unit mounted in the camera accessory shoe or a flash bracket and aim the light wherever you wish. With an auto-flash unit this keeps the sensor, which is mounted in the body, pointed at the subject at all times.

Almost all movable heads tilt at least 90 degrees to point straight up; some go much farther, to point behind the camera; a few also tilt downward. Swiveling aims the flash from side to side. Some units swivel almost a full circle; when combined with tilting, this allows you to point the light almost anywhere.

**Movable Brackets.** These are simply flash mounting brackets that permit you to swivel or tilt the entire unit to control the light direction. They fit in the camera's accessory shoe or attach to the tripod socket. They are fine for manual flash operation, but require a remote sensor for auto operation if moving the unit also moves the main sensor.

*Built-in bounce capability. (Left) A tilt-head unit. (Right) A tilt-swivel head unit. Notice that the sensor of each unit remains aimed straight ahead no matter how the head is positioned.*

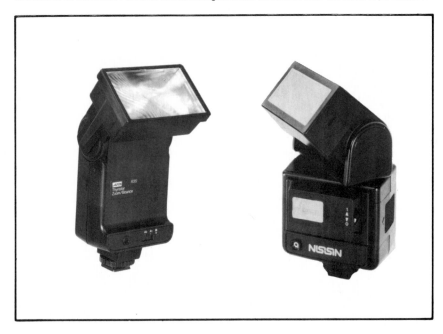

**Two-Tube Heads.** Although bounce light is diffuse, it has definite direction, and that may cause some shadowing, especially under a subject's chin when the light is bounced from above. In addition, bounce light lacks snap and does not put a catchlight in a subject's eyes. One solution is a flash head with two tubes. When the main flashtube is aimed for bounce flash, a smaller tube remains directed at the subject to fill in the shadows and add highlights. There is a tradeoff: the small tube may cause shadows if the subject is too near a background wall, and it takes some power from the main tube; it should be turned off when not needed.

**Bounce Scoop.** Another way to avoid shadowing on the subject is a bounce scoop. This is a central part of the reflector that remains pointed forward when the flash head is tilted for bounce use. The scoop directs 20 to 30 percent of the light forward, the rest is bounced. The scoop also can be rotated when complete bounce is required.

**Flash Flaps.** Many units accept various kind of reflector flaps which act as portable bounce surfaces when the flash head is aimed at them. A *full bounce flap* is an 8 × 10-inch white card which mounts at an angle to bounce the entire flash output toward the subject.

A *fill flap* is a smaller card which catches part of the light and throws it toward the subject when the head is aimed to bounce off a wall or ceiling. You can improvise a fill flap quite easily.

A *catchlight flap* is a clear plastic sheet with a small reflective area. It is mounted on the flash head in bounce mode. Most of the light goes through to the bounce surface, but a small percentage hits the reflective spot and is directed forward to fill in the shadows created by the bounce light.

*(Left) Adjustable shoe accessory has tripod-screw bottom mount; it permits tilting fixed-head flash units for bounce use. (Right) Full bounce flap accessory reflects light forward from a flash head aimed straight up. To improvise this device, tape a white card in a similar position.*

## Ceiling, Walls, and Reflectors

The basic method of bounce is to aim the flash unit at a ceiling or wall, or into a corner to take advantage of both. If these surfaces are too dark, too far away, strongly colored, or otherwise unsuitable, you can use a white painted flat or card. Cards or other reflectors are also useful to prevent shadowing and to add fill light; they are used in essentially the same way as with direct flash.

All bounce surfaces should be white, light cream color, or silver; they should also be matte surfaces to diffuse the light. Colored surfaces will add color to the light, and that will be visible in the white and light skintone areas of the subject. Strongly colored surfaces also may absorb so much light that bounce lighting becomes impractical.

The accompanying illustrations show a variety of bounce flash set-ups; exposure with bounce flash is covered at the end of this chapter.

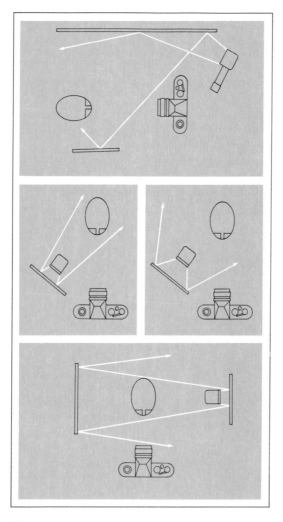

Basic bounce: Aim flash at a point ahead of the subject area so only reflected light reaches the subject. Reflector can help lighten shadowed areas.

Bounce board 45° to 60° to one side of camera provides excellent portrait light. (Left) Placing flash close to board produces relatively narrow reflected beam. (Right) Greater distance spreads light more, may require larger board.

Bounce board at flash unit provides key light. Board on opposite side provides fill; vary its distance to control degree of fill.

## Technique Tip: Bounce Flash Equipment

You may want to use bounce flash frequently for portraits or still-lifes, small objects, and special set-ups. Your first requirement is a flash unit with a fairly high guide number because bouncing the light effectively reduces it by at least one stop. In addition, you will find some or all of the following items to be very useful.

1. One or more light stands with ball-and-socket or clamp attachments sturdy enough to hold a reflector or the flash unit and an umbrella (see the next section).

2. A variety of bounce boards. One 4 × 6 feet or larger (studio or home space permitting) made of white foam-filled board or white painted Masonite, and braces to support it. Two white boards (cardboard; poster or mat board) 2 × 3 feet, and two boards the same size covered with wrinkled aluminum foil. The small boards should have a means for attaching and angling them on the lightstands. You can substitute commercially available collapsible silver cloth reflectors for the foil boards.

3. A white translucent umbrella with a long shaft to adjust its distance from the flash unit.

4. A large piece of white translucent material to serve as a diffuser. Frosted plastic or thin white cloth will do.

5. Dark and light pieces of background material in sizes large enough for the kinds of pictures you want to take.

6. A long sync cord to connect the off-camera flash unit to the shutter.

7. A flash meter (see the section on exposure in this chapter, and Chapter 8).

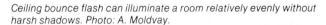

Ceiling bounce flash can illuminate a room relatively evenly without harsh shadows. Photo: A. Moldvay.

## Umbrellas for Light Control

The photographic umbrella is a lighting accessory of great usefulness. Its primary function is to give you a bounce light surface you can take anywhere and place easily in any position. An umbrella is larger than accessory flaps, so it gives you light from a larger area, and it offers much more control over the shape and direction of the light beam. Because it is very lightweight and collapses completely, it is far easier to carry than large cards or other reflectors.

Photo umbrella frames are either square or circular, like rain umbrellas. The square type is less expensive, because it is easier to make, and it can be opened nearly flat to make a broad-area reflector. Circular umbrellas give more directional control; some can be opened to two different settings to act as narrow or broad scoop reflectors. The most useful covering is white, translucent cloth. There are also silvered and gold-tone coverings with either shiny or matte surfaces; these provide greater reflectivity and somewhat harder light than the cloth type. Some umbrellas permit changing the cover material for various effects.

A photo umbrella should have a long shaft so it can be moved closer to or farther from a flash unit on a light stand, to provide light control; various clamps are available for this purpose. An adjustable counter-weight may be needed on the shaft to balance the umbrella at some extensions.

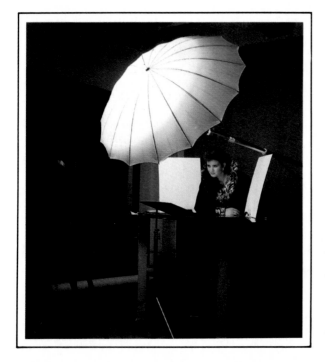

Umbrella light is the mainstay of glamour and fashion photography. A boom or extension shaft provides the greatest flexibility in positioning the light. Reflector cards use the spill light to best advantage, often making only one flash unit necessary.

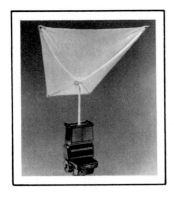

This portable bounce accessory is a great simplification of the umbrella idea. It is lightweight enough to be used with handle-mount flash units on camera brackets, but would strain the mount of hot-shoe units.

**On-Camera Umbrellas.** There are accessory flash brackets that permit using a small umbrella with an on-camera flash unit. The umbrella is held behind your head and the flash unit swiveled to point into it. A highly portable device which eliminates stands, shafts, and brackets, is an inflatable "Air-Brella." It is like a plastic balloon with a transparent side and a white, reflective coating on the other side. It attaches directly to the flash head with two latex bands. The flash is pointed away from the subject, into the Air-Brella. It can be camera- or stand-mounted, or hand-held.

The front light is umbrella flash located just to the left of the camera, slightly above eye-level. The hair light is flash reflected from a white flat to the left rear.

The front light is the same here, but the hair light is direct flash from straight behind the subject. The exposure was the same for both pictures.

## Bounce Flash Exposure

Correct exposure with bounce flash is easy to master with a little experimentation and experience. Two basic factors determine exposure:

1. The total distance the light travels. In bounce photography that is the distance from the flash unit to the bounce surface *plus* the distance from the bounce surface to the subject. The bounce surface may be a ceiling, wall, flat, reflector card, or umbrella.
2. The reflection/absorption characteristics of the bounce surface. You usually have to estimate the effect of this factor, and experience is the best help.

**Tests and Metering.** If you have plenty of time and an easily repeatable set-up, by far the best method of determining correct exposure is to make test shots at various *f*-stops. The processed results will show you everything: light coverage, shadows, contrast, color rendition, and depth of field, as well as exposure. (Professionals widely use accessory Polaroid backs on medium- and large-format cameras to check lighting and exposure on the spot. There are one or two such backs for a few 35mm cameras, but they are very expensive.)

The next best approach is to take a reading with a flash meter. That is an incident-light meter that can respond to the sudden, intense burst of flash illumination but that ignores the existing continuous light. Flash meters are discussed in Chapter 8.

You don't have to invest in a special meter or wait for test shots to be processed, however; you can determine bounce exposure with automatic and manual flash units quite easily.

*Whether you are aiming the flash forward (left) to bounce off a ceiling or wall, or backward (right) to bounce from a corner, reflector, or umbrella, exposure is determined by the total light distance: A + B in both situations.*

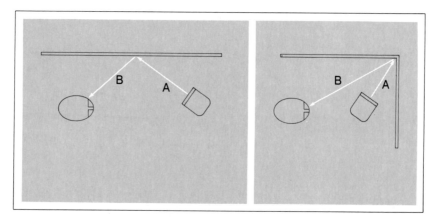

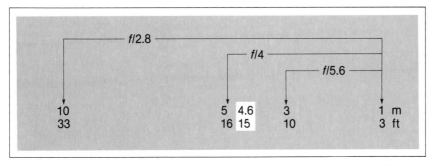

*Although a subject at 4.6 meters is within the f/4 auto-flash range, bouncing light will lose at least one stop of intensity. Only f/2.8 has enough range to ensure adequate auto-flash bounce exposure in this situation.*

**Auto-flash Exposure.** First, the flash sensor must be at the camera position and must be aimed at the subject, no matter where the flash is located or aimed.

Because of the light lost by bouncing, you usually will have to use the largest available *f*-stop for automatic flash control. To choose the *f*-stop, estimate the total lighting distance (flash-bounce-subject distance). Consult the flash dial and choose the *f*-stop whose working range includes that distance within its first half.

For example, suppose the total lighting distance is 4.6 meters (15 ft.), and your auto-flash unit offers a choice of three *f*-stops, covering 1–3 meters (3–10 ft.), 1–5 meters (3–16 ft.), and 1–10 meters (3–33 ft.). These ranges are for direct flash, but you are bouncing the light and will lose some intensity. If you choose the 1–5 meter range, the capacitor will be drained before the lighting job is completed. Your total lighting distance, 4.6 meters, lies in the first half of the larger *f*-stop range, 1–10 meters. You must use that *f*-stop to get auto-flash control.

**Manual Bounce Flash Exposure.** Bouncing flash from the white ceiling or walls of an average size room (8-foot ceiling height) loses about one stop of light. You must adjust for that when you calculate manual exposure, using the total lighting distance (light-bounce-subject distance). Suppose that the distance is 12 feet. Here are two methods:

1. Consult the dial or chart on the flash unit to determine the *f*-stop required for the total lighting distance; set the lens one *f*-stop wider open. (Example: Dial shows *f*/5.6 at 12 feet; use *f*/4.)
2. Divide the guide number for the film you are using by the total distance; open up one stop from the answer. (Example: GN 65 ÷ 12 = 5.4. Round that off to the nearest full stop: *f*/5.6; open up to *f*/4.)

If your bounce surface is a cream-colored wall or ceiling, or a satin-white cloth umbrella, increase exposure a half or a full stop.

# 5

# Multiple Flash

Certain subjects demand more than one light source if you want to obtain the highest quality photograph. That is often the case in taking a portrait. In addition to modeling the face, you may want to highlight the hair, add a catchlight in the eyes, add light to dark clothing, and balance the background with the main subject brightness. You can't do that all with a single light source.

You need more than one source if you want to illuminate a flat object evenly for copying. You also need more than one source to photograph an object with maximum clarity of three-dimensional form, surface texture, and separation from the background.

In some situations you may need more than one light source just to raise the subject brightness to a reasonable exposure level. In other situations you may need to light a large area so a dancer or other moving subject has freedom of movement.

The advantages of using multiple electronic flash units rather than continuous-light sources are the fundamental advantages of flash illumination: It avoids the prolonged glare and heat buildup that can tire or even damage subjects; it has a daylight color balance; its brief, intense burst can stop the fastest action. In addition, flash units are smaller, lighter weight, more maneuverable and more versatile than many tungsten instruments of equal light output.

There are some initial problems in learning to use multiple flash. First, you can't see the composite flash lighting effect as you set up; modeling lights are the basic solution. Second, an ordinary light meter cannot give you exposure indications; a flash meter can, or you can quickly determine how to set up the lighting for a desired exposure without the need for a meter or skill in higher math. Third, you may have to use some automatic flash units on their manual settings; this may seem a limitation, but actually it is more convenient and will give you more accurate control of exposure.

*Some sports arenas are equipped with multiple high-power electronic flash units which can be fired in unison by a trigger pulse from a radio transmitter connected to a camera. You can get the advantages of multiple flash much more easily, and on a less complex scale, with even the simplest of flash units; this chapter explains how. Photo: P. Bereswill.*

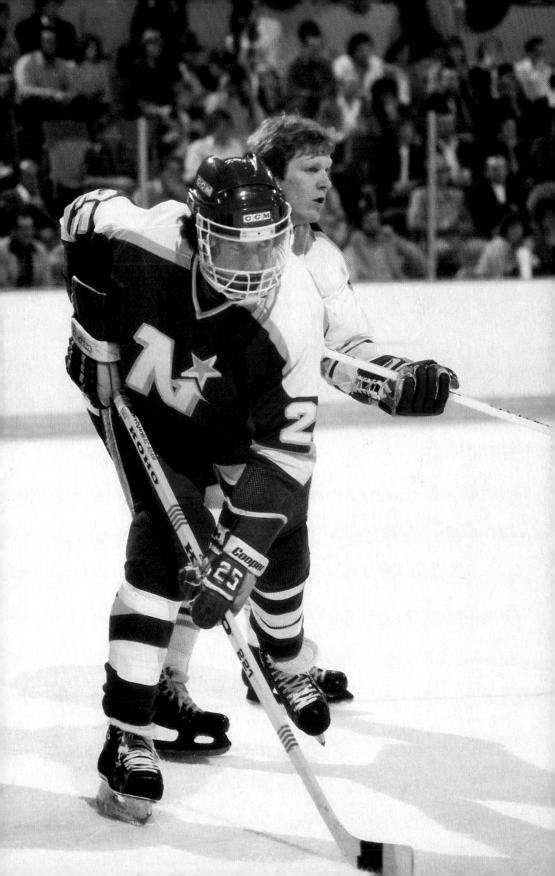

## Synchronizing Multiple Flash

When you use multiple flash, all the units must fire at the same instant, in sync with the camera shutter. There are two ways to accomplish this: with interconnecting sync cords, or with wireless trigger switches called slave switches, or simply slaves.

**Slave System.** By far the most versatile method of multiple flash sync is to use a photoelectric slave switch plugged into each unit. Only one unit needs to be directly connected to the camera; it becomes the master—all others are slaves because their switches obey a trigger signal from the master. It is a tremendous advantage not to have wires running to every unit. You can place a unit almost anywhere, without restriction, and can easily conceal it behind an object in the picture area.

Most slave switches respond to the burst of light from the master unit; others respond to a pulse of infrared energy from a special unit at the camera. In either case, each slave switch must be able to see the master signal. Some slaves have a very narrow angle of acceptance and must be carefully aimed at the master; wide-angle slaves with almost a full circle of acceptance can be positioned much more freely. If a flash unit is hidden in the scene, its slave switch must be connected with an extension cord and located where it can receive the trigger signal.

Certain slave switches can be fired only by a specific matched flash unit. The master unit actually emits two pulses of light, a weak one that arms the slave, then a stronger flash that triggers it; the flashes happen so fast that you can't distinguish between them. This arrangement prevents the slave unit from being fired by any other units in the area, a good protection when you are shooting on location along with other photographers.

Infrared-sensitive slaves are useful when you want no direct light on the subject from the camera position. The master unit at the camera is really just a low-powered electronic flash with a deep red filter. Many slave switches are sensitive to infrared and can be used with such a master.

Some photographers trigger non-IR slave switches with a very low-guide-numbered unit at the camera, relying on the fact that the amount of light it produces is so small that it has virtually no influence on the final picture. However, it must produce enough light to trigger the most distant slave. Slave switches have various degrees of sensitivity; that determines not only their maximum working distance, but how bright the ambient light can be. A low-sensitivity unit can be used in bright surroundings without being triggered by the existing light. Some slaves have high and low settings so you can adjust for the situation or for extended working distances; this is the most versatile type.

**Technique Tip: Slave Connections**

Some portable electronic flash units have built-in slave triggers, but a separate switch is more flexible. Slaves are provided with various connectors to couple them to flash units; they include:

1. H-plug, similar to the plug of an electrical cord.
2. PC cord, with a variety of connectors at the other end.
3. Hot foot, for mounting in an appropriate show on the flash unit.

Your best choice is a slave with a wide angle of acceptance, high-low sensitivity settings, and at least two different means of flash connection so you can use it to trigger more than one unit if necessary. Some slaves also have a tripod socket for mounting —a helpful feature in many set-ups.

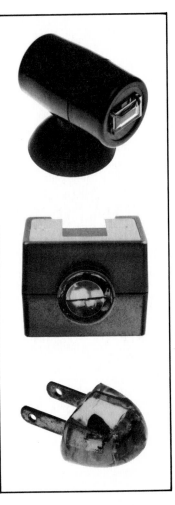

Slave switches and connectors. (Right top) suction cup foot secures switch to most surfaces. Sensor must point in general direction of master unit. Uses PC connector. (Center) Switch mounts on foot of shoe-mount flash units. It has a tripod screw socket on bottom for mounting; Must be aimed toward the master unit. (Bottom) Omnidirectional H-plug switch encapsulated in clear epoxy can see light from any direction except plug side. (Below) Adapter cords for PC-H connections.

Three flash units were used for this picture: an umbrella unit on each side of the camera, and a direct flash unit from the left rear. In close range set-ups and studio work it is easy to use either a wired or a remote-slave system for multiple flash. Photo: B. Bennett.

On location, a wired multiple flash set-up is seldom practical, or safe from accidents; slave remote units are almost essential. Here, light from the master unit at the camera tripped a slave on the upper left level for a unit lighting the ceiling, and a second slave for a direct backlight unit on the upper right level. Photo: B. Docktor.

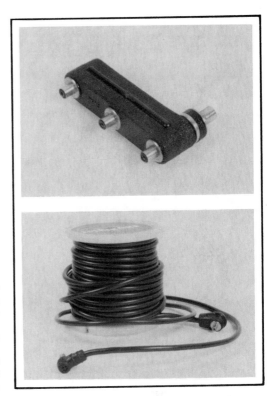

*Essential accessories for wired multiple flash set-ups. (Top) Multiple PC connector; various configurations are available. (Bottom) Extension PC cord; one for each remote unit is needed, and perhaps one to reach to the camera if a long distance is covered.*

## Wired Sync System

Rather than invest in slave switches, it is less expensive to interconnect multiple flash set-ups with extension sync cords. Some flash units can be connected in series, with a single cord running from one to the next and to the camera. More often you will need one or more Y-cords or multiple PC connectors to divide the sync line from the camera into a branch to each unit. (If your camera has only a hot shoe, you can get a shoe-to-PC adapter for making sync cord connections.)

Cord systems are best in limited shooting situations such as close-up and still life photography. Long cords may have enough electrical resistance to cause a unit to fire late, or not at all. Cords limit the off-camera distance of units and they may present hazards to moving around, especially if each unit is also plugged into an a.c. outlet.

The major question is whether you can use a wired system at all. Some cameras can be connected to only one flash unit; a heavier load will burn out the shutter sync contacts. Other cameras can be connected to multiple units only of a certain kind, or with a certain output limit. And some flash units cannot be connected to others. *Examine your camera and flash instructions very carefully.* If you can't find the answer, contact the manufacturer. Do not go ahead without knowing —it's expensive to repair or replace damaged equipment.

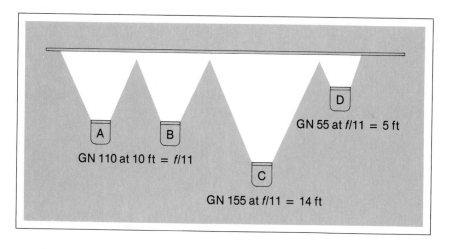

GN 55 at f/11 = 5 ft

GN 110 at 10 ft = f/11

GN 155 at f/11 = 14 ft

*Units A and B have equal output, so they are placed at equal distances from the surface being lighted. Higher output unit C is placed at a greater distance to match the f-stop for A and B. Lower output unit D is placed closer to match.*

## Large Area Lighting

One of the simplest but most valuable uses of multiple flash is to light a large area evenly. Your subjects might be in a big room or a gym, on the dance floor, on stage, in a swimming pool, on a skating rink, or any number of places. By illuminating the entire area evenly you can take overall shots or move in for details using the same exposure—that's a great working convenience, especially if you want to work rapidly and concentrate on how the subject is moving and changing. Using electronic flash ensures that you can stop movement sharply in all your shots.

**Setting Coverage and Distance.** First make sure that the area each flash unit covers does not significantly overlap any other. If no more than one-fourth of adjacent areas overlaps, the coverage will be reasonably uniform, without hot spots. Second, equalize distances. If all your flash units have the same output (equal guide numbers), place them all the same distance from the areas they cover. If the units have different outputs, set them at distances that require the same f-stop. Place one unit at a convenient distance and determine the f-stop it will require for proper exposure. (Use the distance dial on the unit, or divide the guide number by the set-up distance.) Use that f-stop to determine the set-up distance for any other unit. Either look at the distance opposite that f-stop on the unit's dial, or divide its guide number by the f-number. The illustration will help make this clear.

Your exposure will be at the f-stop required for any one unit. Since the distances for all units are equalized and the light does not significantly overlap, it will be the same throughout the area.

## Increasing the Light Level

When the subject is too dark, or when you want to use a smaller $f$-stop, you can use multiple flash to increase the light level as much as you need. Just aim more than one flash unit at the same area, all from the same direction, or as nearly the same as possible. If you have automatic flash units, set them for manual operation; otherwise each sensor will respond to the increased light and will shut off its unit far too soon.

   Place units of equal output all the same distance from the area you are lighting. If they have different outputs, vary the distances so that they all call for the same $f$-stop. Work from the distance/$f$-stop dial on each unit, or use the unit guide numbers; the illustration gives you an example.

   Exposure will change as you add light. Each time you double the amount of light, you change exposure by one $f$-stop. Start with the $f$-stop required for one unit and use the following table to determine either how many $f$-stops to close the lens, or how many units you need to get enough light for the $f$-stop you want to use. A three-stop increase in the light is a practical limit; by that time you need eight flash units, and the set-up is likely to get out of hand.

### INCREASING LIGHT WITH MULTIPLE FLASH

| Relative Amount of Light (units) | Light Increase | | No. of Equal-Output Flash Units Required* |
|---|---|---|---|
| 1 | — | | 1 |
| 2 | +1 stop | (2X) | 2 |
| 4 | +2 | (4X) | 4 |
| 6 | +2½ | (6X) | 6 |
| 8 | +3 | (8X) | 8 |

*Or units of different outputs, placed at equalized distances.

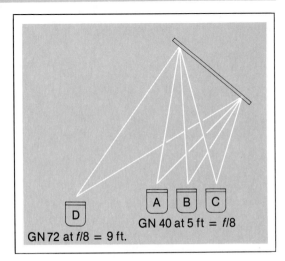

Units of equal output—A, B, C—are placed equal distances from the area lighted. Higher output unit D is placed at a distance to match.

GN 40 at 5 ft = f/8

GN 72 at f/8 = 9 ft.

## Dimensional Lighting with Multiple Flash

The major use of multiple flash is to create three-dimensional modeling of the subject and bring out surface characteristics such as color and texture. The basic procedure is as follows:

1. Establish a direction and distance for a main or key light.
2. Add a weaker fill light from a different direction to lighten but not eliminate the shadows created by the key light.
3. Add a backlight from behind and above the subject to outline its edges and separate it visually from the background.

This is the fundamental approach to multiple-source lighting whether you are using flash or continuous light sources; it is equally appropriate for lighting a portrait subject, a single object, or a group of objects. The lighting can be amplified by adding sources to light the background, to deal with especially dark areas of the subject, or to create special highlights, for example in the hair or eyes.

**Three-light Balance.** The balance between the key, fill, and back lights establishes the lighting pattern, no matter what other special-purpose lights you may add. The backlight almost always must be one to one-and-a-half stops (2× to 3×) brighter than the key light, otherwise its effect on the subject edges will be washed out. However, the backlight does not contribute to the basic exposure; that is determined by the front light brightness.

The key and fill lighting ratio determines the front light brightness. In general, calculate exposure from the output and distance of the flash unit you use for the key light. However, when the angle between key and fill positions is 90 degrees or less, you need to make the following adjustments:

| Lighting Ratio | Exposure Adjustment |
|---|---|
| 2:1 | −1 stop from calculated key light exposure |
| 3:1 | −½ stop from calculated key light exposure |

The reason for the adjustment is the overlap of the key and fill lights on the front of the subject, as explained in the Technique Tip. When the angle between these two lights is greater than 90 degrees with a three-dimensional subject, or when the lighting ratio is 4:1 or higher, the overlap is insignificant in effect. In those cases, use the exposure calculated for the key light without adjustment.

### Technique Tip: Understanding Lighting Ratios

A lighting ratio is the difference between the strongest and weakest amounts of light *falling onto* the subject. In the ratio the fill light is always given as one unit of light (3:1, 5:1, etc.). The larger number is not the relative brightness of the key light, it is the brightness of the key *plus* the fill light because these two overlap on some parts of the subject, so their light units add together.

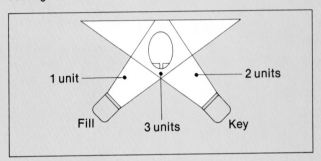

For example, if the key light is twice as bright as the fill, it is supplying two units of light while the fill is supplying one unit. Where they overlap, the subject is receiving *three* units of light. Therefore, the true lighting ratio is 3:1 Other ratios are as follows:

| Lighting Ratio (Key-plus-fill to Fill) | Degree Key-only Is Brighter than Fill | |
|---|---|---|
| 2:1 | 1.5X or | ½ stop |
| 3:1 | 2X | 1 stop |
| 4:1 | 3X | 1½ stops |
| 5:1 | 4X | 2 stops |
| 7:1 | 6X | 2½ stops |
| 9:1 | 8X | 3 stops |

As explained in the text (following pages), you can calculate lighting ratios from light source-to-subject distances, or from the required difference in *f*-stops.

Note that the subject brightness ratio (the ratio between the brightest and darkest amounts of light *reflected from* the subject) is the same as the lighting ratio only when the subject has uniform reflectance—a face for example. If one part of the subject is more reflective than another, the brightness ratio may be quite different. In practice, light set-ups are made for a desired lighting ratio, then the exposure may be adjusted according to the reflectance characteristics of the subject.

## Establishing Multiple Flash Set-ups

Your first question in using multiple flash will be: Where do I put the flash units to get the effect I want? The answer is easy to get if you work step by step from key to fill to backlight.

**Key Light.** Examine the subject to decide the best direction for the main light. Almost never is it from the camera position; most often it is from about 45 to 60 degrees to one side and somewhat above camera level or subject eye level. You can use a continuous light source to judge the general effect if you wish.

Next, establish the distance from the key unit to the subject. If you want to take the picture at a particular $f$-stop, use that to determine the distance. Refer to the distance/$f$-stop dial on the unit, or divide the unit guide number by that $f$-number. If working distance is important, position the key unit to give you the required room; then use that distance to determine the key unit $f$-stop, using the flash dial or dividing the distance into the unit guide number. In either case, you must know the key unit $f$-stop to determine exposure, as explained previously, and to determine fill light placement.

**Fill Light.** With the key light off the camera, the fill light should come from the camera position or from the side opposite to the key light. If you are using flash units of matched output, see the Technique Tip for ways to make a quick set-up. Most often the fill unit will have a different output from the key unit; in that case proceed as follows.

Decide what lighting ratio you want to use; for color film keep it at 5:1 or less. From the ratio determine how many $f$-stops difference there must be between the key and the fill intensities. Refer to the key unit $f$-stop (already established) and count down (to a lower $f$-number) as many stops as the key-fill difference. Use the $f$-number you arrive at to figure the fill unit distance.

Here's an example: You want a 5:1 lighting ratio; that's a two-stop difference between key and fill. The key unit $f$-stop for the distance you have set it up is $f/8$. Counting down two $f$-stops from that brings you to $f/4$. Find the distance opposite $f/4$ on the fill unit dial, or divide its guide number by $f/4$. Place the fill unit at that distance. Now, when you make the exposure at the key unit $f$-stop ($f/8$) the fill light will be two stops underexposed (full exposure would require $f/4$), and that's just what you want.

**Backlight.** Your approach to setting up the backlight is the same as with the fill light, except that you want to put it at a distance to make it one $f$-stop *brighter* than the key light. So, count one $f$-number higher than the key $f$-number and use that to figure the backlight distance. Again, use either the unit dial or its guide number. In the example case you would count from $f/8$ (key) to $f/11$ (backlight) and place the unit

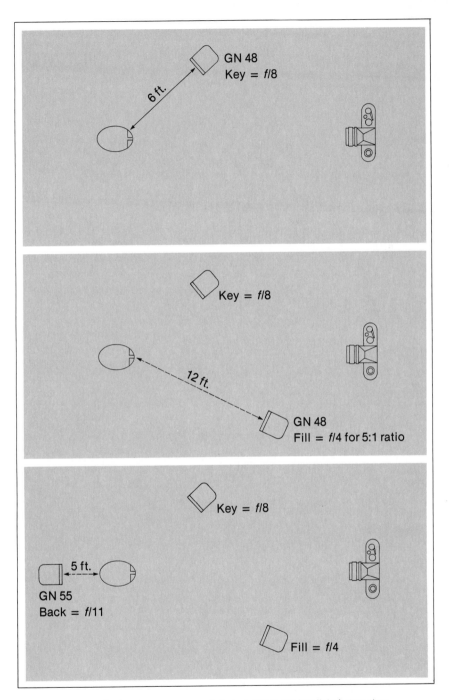

GN 48
Key = f/8

6 ft.

Key = f/8

12 ft.

GN 48
Fill = f/4 for 5:1 ratio

Key = f/8

5 ft.

GN 55
Back = f/11

Fill = f/4

*Making a multiple flash set-up; see example in text. Establish key light f-stop, then determine fill and backlight distances from their f-values relative to the key.*

at the resulting distance. Then, when you expose at $f/8$, the backlight (which requires only $f/11$ for full exposure) will be one stop overexposed—and that, too, is what you want.

### Technique Tip: Lighting Ratio Set-up

If you use flash units of equal output (equal guide numbers), you can quickly set up a lighting ratio by varying their outputs or by placing them at distances equivalent to *f*-numbers. Here's how:

1. If your units have a variable output selection feature (full, half-, quarter-power, etc.), place them all the *same distance* from the subject. Set the backlight unit for full power. Set the key unit output for one stop less light than the backlight. Set the fill unit for an output one, two, or three stops less than the *key unit;* the difference will depend on the lighting ratio you want. Check your flash unit instructions carefully to see what output setting reduces the light by one stop. If the instructions refer to changed guide numbers, remember that cutting a guide number in half reduces the light output by *two* f-stops; a one-stop reduction reduces the guide number by only 0.7X.

2. If your units do not have variable output selection, use them all at the same distance, but cover the key unit with one layer of white handkerchief, and cover the fill unit with two, three, or four layers of the same density cloth. Leave the backlight unit uncovered.

3. The most precise way of setting up non-variable equal-output units is to place them at distances equivalent to *f*-stops. Set the key unit at a distance equal to any *f*-number—say 5½ feet, which is equivalent to *f*/5.6. Set the fill unit at a distance equal to an appropriately higher *f*-number, according to how many stops difference you need between key and fill for your lighting ratio. For example:

| Key Distance (feet) | Fill Distance (feet) | | Difference | | Lighting Ratio |
|---|---|---|---|---|---|
| 5½ (= *f*/5.6) | 5½ | | — — | | 2:1 |
| 5½ | 8 | (= *f*/8) | 1 | stop | 3:1 |
| 5½ | 11 | (= *f*/11) | 2 | stops | 5:1 |
| 5½ | 16 | (= *f*/16) | 3 | stops | 9:1 |

To make the backlight one stop brighter than the key, place it at a distance equal to the next lower *f*-number—4 feet (*f*/4) in this example. If you wanted the backlight one-and-a-half stops brighter, you would place it at 3½ feet, because *f*/3.5 is halfway between *f*/4 and the next full stop, f/2.8.

*Full frontal lighting with a single umbrella unit, used for this picture, was easy to set up with the aid of a modeling light to see exactly where the light was aimed and how the shadow fell on the off-side cheek. The front light was positioned first, then the background lights were added. They are about two stops brighter than the front light to give a white background; some of their reflected illumination helps soften the shadow on the face. Photo: G. Chinsee.*

## Seeing the Set-up

The problem with flash is that you can see where the units are pointing, but you can't see what the light will do. Only a test shot can show you exactly what you will get with multiple flash. That is seldom practical unless you can hold your entire set-up until the test film comes back from processing, or unless you can put an instant-print back on your camera (very few 35mm cameras permit this, and the back is a very expensive accessory).

**Modeling Lights.** One way to judge multiple flash set-ups is with a modeling light at each unit. This is simply a tungsten bulb that is turned on to throw light on the subject approximately the way the flash will. The effect is not an exact simulation of the flash, and of course it is less intense, but it will let you see where shadows fall and how well they are filled in.

Some flash units have built-in modeling lights, others have them available as accessories. You can also make up your own with sockets, cords, and bulbs from the hardware or electrical store. Use self-contained reflector spot or flood bulbs. If your flash units all have the same output, use the same strength modeling light for each one. If they have different outputs, determine the differences between them in $f$-stops. Either compare guide numbers or set them all for the same film speed and compare the $f$-stop called for at the same distance, say 15 feet, on each unit. Then use a light meter to find various wattage bulbs for your modeling lights that have comparable $f$-stop differences in their outputs.

When using modeling lights with direct flash, keep them as close to the actual flash unit position as possible. If you are going to bounce the flash, aim the modeling light at the subject from the final angle of bounce. Don't try to bounce the modeling illumination itself, the light is too weak to be seen clearly.

## Typical Set-ups

The illustrations on these pages show you a number of ways to make multiple flash set-ups for various effects. Notice that you can use either direct or umbrella (or reflected) flash for a key light while you use direct flash for a backlight, and perhaps even for fill. Notice too that one or two reflectors can give you the equivalent of a three- or four-light set-up with only two flash units.

*The kittens below were photgraphed by the simplest of two-light arrangements, as diagrammed at the right. The front light was direct flash from the left; the backlight was 180° opposite, but at a higher angle. Photo: K. Bancroft.*

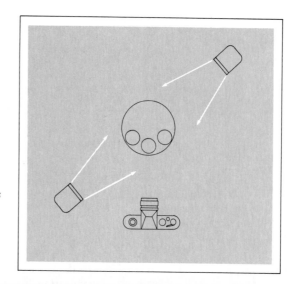

A three-light multiple flash set-up was used for this still life. See if you can figure out the arrangement before looking at the diagram below; the shadows and the reflections on the vase will help. Photo: C.M. Fitch.

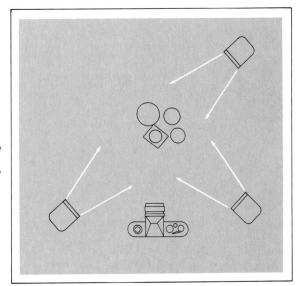

All three flash units were diffused. The backlight was strongest and at the highest angle. The main light at the right front was at the level of the flowers in the vase. The fill light at left was the weakest; its height was about halfway between that of the main and the backlights.

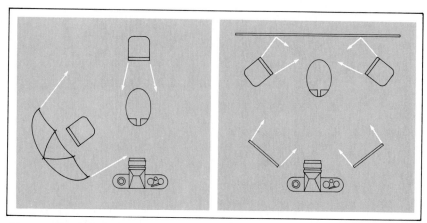

Glamour effect: Soft front light from umbrella, rim light or halo from direct backlight unit hidden by subject's body.

Soft light, white background: Reflectors pick up light bouncing off background. Move one reflector closer for more front modeling.

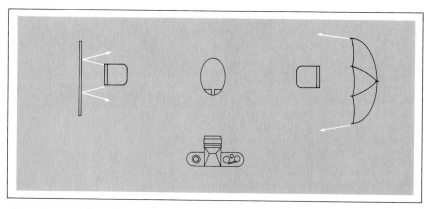

Either the umbrella or the bounce board can be the key light source, depending on the unit output and the distance from the subject. Vary the effect by using the bounce board without a flash, to pick up spill from the umbrella.

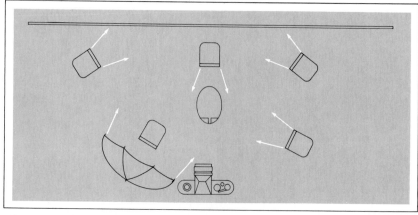

Classic five-light set-up: Two units for background; umbrella key light; direct flash units for fill and backlight. Slave trigger switches make it easy to use this many lights.

## Exposure with Multiple Flash

Some exposure recommendations have already been given in this chapter; they are summarized here along with additional information about determining exposure for multiple flash situations.

1. For the most precise control, use the flash units in the manual mode of operation.
2. Use a flash meter for the most accurate indication of required exposure.
3. Without a meter, calculate exposure (by guide number or flash unit dial) from the distance from the key light unit to the subject; ignore the backlight. Use this exposure: (a) when the angle between key and fill units is greater than 90 degrees, or (b) when the lighting ratio is 4:1 or higher, no matter what the angle is between key and fill units.
4. If the angle between the front lights is 90 degrees or less, you must reduce the exposure calculated from the key light position. Use one stop less exposure with a 2:1 lighting ratio, or a half-stop less exposure with a 3:1 lighting ratio.

**Manual vs. Automatic Flash.** It is difficult, but possible, to use one or more flash units on manual and others on automatic. Use the automatic units as fill, accent, or background lights (but not as backlight on the subject). Use the key light on manual.

The problem of course is that each auto-flash sensor will see more than the light from its own units and will shut it off too soon. You can achieve some limited control if your auto-flash unit offers a choice of more than one f-stop. At the largest f-stop setting it will shut down almost immediately from the combined intensity of fill plus key light it receives. Instead, choose a smaller f-stop setting; that will change the sensor reaction time so that the unit will remain on longer and send out more light. Only experimentation will show you how to achieve this kind of control.

Using both front-light units on automatic is also possible, but very unpredictable. It will work when there is little overlap of the two lights. That occurs when the angle between them is quite large, or when one is used primarily to light an object in the background.

# 6

# Special Techniques

There are ways to use electronic flash to achieve special effects or solve difficult photographic problems that can be applied to a wide variety of subjects. This chapter shows you how to light subjects larger than a multiple flash set-up could handle; how to isolate a subject in a pool of light; how to achieve ultra-fast exposures, on the order of 1/50,000 sec.; how to take rapid sequences; and how to achieve a variety of color effects.

**Multiple Exposure Color.** A common way to achieve multiple images of the same subject on a single frame is to lock the shutter open on B and fire the flash unit repeatedly as the subject changes position against a dark background. To add visual interest to this technique, make each exposure a different color. You could change filters in front of the camera lens, but that is hard to do without disturbing the camera, and involves different exposure compensations. It is far simpler to use an automatic flash unit and change filters in front of the flash head; the unit sensor will take care of exposure changes.

Many variations of this technique are possible, but there are some basic precautions in all cases. To get clean, distinct images, the room and the background must be very dark or black; if they are light, you will get ghost images and background show-through. Plan the various subject positions to avoid significant overlapping; areas with superimposed images will be overexposed. If the surroundings are not black, arrange to block the camera lens between flashes to prevent exposure buildup from the ambient light. In addition, use a slow film and as small an $f$-stop as possible. To see the color effects most clearly, use a model dressed in white. For the fullest images, use a weak fill-light flash with no filter or a different color filter from the key light. For a variety of image sizes, change lens focal length or zoom lens setting between flashes. In this last case you will need a camera with multiple-exposure capability so that the film will be protected during lens changes.

*A black background makes it easy to simulate a stroboscopic motion sequence. Each time the ball was repositioned, the flash was fired. Strong sidelighting left one side of the ball dark to minimize overlap problems. Photo: D. Garvey/West Stock, Inc.*

## Flash Color Effects

The multiple exposure color effects explained on the preceding pages require special set-ups and techniques. You can create a variety of single-exposure color effects much more easily, in all kinds of situations —simply place a filter in front of the camera lens or the flash head, or both. A camera-lens filter will affect the entire picture; a flash-head filter offers greater selectivity because you can use the flash to illuminate the subject, the background, or any other area you choose.

Filters for flash units do not have to be of optical quality, as camera filters do, because they are not in the image-forming path and thus cannot affect sharpness or cause distortions. Many flash manufacturers offer filter kits, but the color selection is limited. Art supply, camera, and theatrical lighting stores sell acetate and plastic materials in many different hues. You can use them as flash filters by fastening them in place with rubber bands or tape.

It is easiest to use a filter in front of an automatic flash unit because the sensor will deal with the reduced amount of light. If you use a filter with a manual unit, or put it on the camera lens, you must change the lens aperture to a larger setting to compensate for the light absorbed by the filter. If you do not know the filter factor, take exposure readings of a white card or wall through the filter and without the filter; compare the difference in $f$-stops and scratch it into the filter edge, out of the field of view.

**Color Balancing.** Electronic flash closely matches the color balance of daylight type color films. If your pictures look a bit "cold" or bluish, try a light yellow or magenta color compensating filter (CC10Y or CC10M), or an 81A or 81B filter in front of the camera lens. A one-third to one-half stop exposure correction will be required with most subjects.

To use tungsten type color film, put an 80A conversion filter over the camera lens and make a two-stop correction for properly exposed, natural looking colors. (Use an 80B filter and one-and-a-half stops exposure correction with Kodachrome 40, a 3400K, Type A color film.)

Many flash units have accessory filters like these to match the flash output to tungsten type color film, to diffuse or reduce the light, or to achieve other corrections and effects. The filters fit directly over the flash head lens.

*Double filtration achieved this effect. A purplish filter on the camera lens colored the background, but it neutralized the effect of a yellow filter on the flash so that the foreground subject colors appear normal. Photo: Cokin.*

**Subject-Background Effects.** Use tungsten film outdoors with a conversion filter on the flash head, not the camera lens (some units have an accessory tungsten filter). Keep the flash-illuminated subject well forward of the background. The result will be a natural color subject and a background with a heavy blue cast, the result of the mis-match between film and daylight.

To get a strangely colored subject outdoors in natural color surroundings, use daylight film with a colored filter over the flash head. Again, keep the subject well forward of the background to avoid flash spill on the surroundings.

In either approach, select a shutter speed and *f*-stop combination that will register the background light equally with the flash exposure. This is essentially the same as figuring out 1:1 flash fill, as explained in Chapter 3.

For unusual background color, other than tungsten-film blue, use a strongly colored filter on the camera lens, and an opposite (complementary) color filter on the flash unit. The lens filter will neutralize the colored flash so the subject will appear natural, but the background will be changed. Some filter manufacturers offer filter sets of colors matched specifically for this effect. Use the flash on manual, and add exposure compensation for both filters. You'll need to experiment at first.

In multiple flash set-ups, leave the key light unfiltered, but filter the fill light to give subtle hints of color in the shadows. If you use separate background light, filter it to change a white surface to any color you want.

## Painting with Flash

With a little forethought and sufficient time, you could use a single portable flash unit to light the facade of the White House, or the interior of a convention hall. Or you could provide shadowless lighting on a large subject with a great variety of protrusions and recesses—the array of components packed together under the hood of a car, for example.

The technique that would let you do this is called painting with flash. Simply enough, when the flash coverage is smaller than the area you need to light, or when you need light from several angles to wash out shadows, proceed as follows:

1. Use a medium- or high-speed film.
2. Mount the camera on a tripod.
3. Open the shutter on B (bulb) or T (time), using a locking cable release for the B setting.
4. Fire the flash repeatedly, using the "open flash" or "test" button. The flash unit should not be connected to the camera. Aim it at a different part of the subject each time (unless several flashes are required on the same area to build up proper exposure) until everything has been evenly illuminated.

There are some basic precautions in any painting-with-flash situation. Do not let coverage areas overlap very much, or overexposure in the overlaps will give spotty results. Do not stand where the lens can see you, or you may register as a ghostlike image on the film. Make sure that the flash is never turned so that the camera can see any part of the flash lens; the result would be a bright blob in the picture.

You can use either an automatic or a manual unit to paint with flash. If your unit has a "zoom" head or accepts accessory lenses to change the light coverage, use this capability to advantage. Telephoto flash throws the light to a greater height or distance; wide-angle flash covers a broader flat area.

**Painting with Auto-Flash.** An automatic flash unit is the easiest "light brush" to use because it lets you move freely and compensates the exposure each time, so long as you stay within the distance range of the $f$-stop you have selected. Choose an aperture with a working distance that will take in the highest or farthest part of the subject, and that provides adequate depth of field. A unit with a confidence (confirmation) lamp is especially useful because it signals when each flash is sufficient.

**Painting with Manual Flash.** A manual flash unit requires more planning and care than an automatic unit. You must calculate the required flash distance after you have chosen an *f*-stop that gives you good depth of field. Then you must be sure that the flash unit is exactly that distance from the subject each time you fire it. You may need to go through the area before starting to measure off and mark the spots where you will stand. If the calculated distance is too close to some parts of the subject, move to twice that distance and fire the flash four times.

### Technique Tip: Ambient Light and Painting with Flash

Painting with flash is easy outdoors at night or in very dark interiors because there is little or no existing (ambient) light to build up exposure even though the shutter is continuously open. However, if you paint with flash under daylight conditions, overexposure buildup can occur. This is often a problem when shooting large interiors with daylight coming in the windows. There are two solutions; often it is best to combine them.

1. Have an assistant block the lens with a black card as you move around between flash exposures.

2. Choose a very small *f*-stop so that the amount of ambient light reaching the film is kept to a minimum. That may be an *f*-stop much smaller than what is required for your actual flash-to-subject distance, but you can overcome that as follows:

| If lens is set this many *f*-stops smaller than the flash-subject distance calls for | Fire the flash unit this many times to paint in a particular subject area |
|---|---|
| 1 stop | 2 times |
| 2 stops | 4 times |
| 3 stops | 8 times |
| 4 stops | 16 times |
| 5 stops | 32 times |

Be sure to let the unit recycle completely after each firing.

*An ultra-brief burst of light caught the individual droplets of spray in flight. Photo: M. Frank.*

## Ultra-fast Flash

The short pulse of light an electronic flash unit emits can stop a diver in mid-air, halt a water droplet falling from a faucet, or stop the motion of a bird's wings in flight.

In general, a manual flash unit can be used to freeze movement in actions that humans can perform. Manual units have a non-variable flash duration, usually somewhere between 1/1000 and 1/2000 of a second. This is not fast enough to record truly high speed phenomena, but it is more than adequate to catch a swimmer's splash or an acrobat's back flip.

However, if you want to record events in the "unseen" world where things happen so fast your eyes cannot perceive anything, you will need an automatic flash unit. That is because its flash duration is variable from about 1/1000 sec. to as short as 1/30,000 or even 1/50,000 of a second.

**Flash Scoop.** You can get these very short burst of flash by working very close to the subject. At greater distances you must trick the sensor into responding as if it were very close. The simplest way to do this is with a "flash scoop," which reflects a small amount of light directly into the sensor as soon as the flash tube fires. Since the sensor detects the light immediately, it shuts down and creates an extremely short flash.

Make a scoop with a piece of white paper or a strip of aluminum foil. Bend and tape it so that a small part of the scoop is in front of the flash lens; secure the other end below the sensor. The scoop should look like a semicircle; it should not touch the sensor, but should channel light by reflection from the flash tube to the sensor.

If you have a variable-output flash unit, a scoop may be unnecessary. Most such units provide reduced output by cutting off the flash duration sooner than usual (that's exactly what you use a scoop on a

fixed-output unit for). If your unit has a $\frac{1}{32}$ or $\frac{1}{64}$ output setting, try that for high-speed shots. If the smallest output setting is only $\frac{1}{8}$ or $\frac{1}{16}$, leave the unit set for full output and add a scoop.

**Exposure.** It is difficult to determine proper exposure with ultra-short flash bursts. At normal subject distances far too little light is produced for you to rely on the auto-flash range dial. You will need to open the lens at least one *f*-stop more than in normal flash use, and perhaps as much as three or four stops. In very close-up situations, where you get immediate flash cut-off even without a scoop, you may be so close that overexposure will result. A neutral density filter over the camera lens may be the answer.

The best way to determine exposure is with a flash meter; the next best way is to make test shots and keep careful notes on the set-up, *f*-stops, and other factors. Exposure may be complicated by the reciprocity effect. That is the failure of the film to build up normal exposure effect when the exposure is extremely brief. The basic correction is to open the lens an additional amount. Check your flash unit specifications; if the shortest duration it produces is about 1/10,000 sec., open up a half-stop more; if it is 1/30,000 to 1/50,000 sec., open up a full stop for test shots.

Your own reaction time is also a factor. At best, your response time is about a fifth of a second, which is very slow in the realm of high-speed events. It is difficult to press the shutter release at the exact moment necessary to capture an invisibly fast event. The standard procedures in this kind of photography are to experiment, bracket exposures extensively, and expect a small percentage of real success.

To catch this drop in mid-air, a small automatic flash unit was rigged with a scoop, as described on the opposite page, so that the sensor would cut off the flash output as fast as possible. Exposures were made at various f-stops because it is almost impossible to calculate exactly the aperture a situation like this will require. Photo: M. Frank.

## Motor Drives and Electronic Flash

Before energy-saving thyristor circuits were introduced into portable flash units, photography with a motor drive was not feasible. Today, however, a few small and many medium- and high-power units have an MD (motor-drive) setting or capability. This allows you to shoot at two, three, five or more frames per second.

The primary limitation in using flash with a motor drive is that the flash unit cannot work at full light output. Suppose you have a flash unit that recycles in three seconds when set on manual. If you wanted it to recycle in 0.3 sec. to sync with your autowinder or motor drive, it would have to be nearly nine times bigger to house a capacitor that could store the necessary energy; the size and cost would be impractical. The solution to fast recycling is instead to reduce the flash output for each shot.

Setting a flash unit to MD cuts the output to the minimum; $\frac{1}{64}$-power is the most likely output. That of course reduces the effective guide number. You must use the manual mode when you set an auto-flash unit for MD use, and calculate the $f$-stop from the flash-subject distance and the reduced guide number. You will soon discover that your working distance becomes quite short. For example, the MD setting on a typical unit reduces a guide number of 80 to 10. At a 10-foot distance that changes the $f$-stop required for proper exposure from $f/8$ to $f/1$! (Compare: $80 \div 10 = 8$, and $10 \div 10 = 1$.) Obviously, a high speed film is a necessity to give you as much guide number advantage as possible, both for working distance and to use an $f$-stop that has reasonable depth of field.

**Non-MD Units.** The intructions for some thyistor auto-flash units claim that they can be used with motor drives even though they do not have an MD setting. Indeed they can—on automatic, at the widest possible working aperture, and at very close distances so that only a small portion of the stored energy is used and the recycling time is very fast. However, you'll get a very limited number of exposures—two or three frames at ten feet, perhaps—before the capacitor is depleted.

*You need a combination of motorized film advance and a synchronized flash unit to capture this kind of picture. Only a brief burst of shots is required at the peak moment of action; that is one of the secrets of using motor-drive flash successfully. Photo: K. Kaminsky.*

## Telephoto and Wide-angle Flash

The reflector and lens design of a portable flash unit spread out the light to match the coverage of a normal focal-length lens. That wastes light outside the picture area if you use a telephoto lens, or leaves the edges of the picture underlighted if you use a wide-angle lens. To give you more flexibility, some flash units have a "zoom" head with a lens that moves to various positions to change the flash coverage. Other flash units accept accessory telephoto and wide-angle converter accessories for the same purpose.

Changing flash coverage creates an exposure change because the same amount of light is either concentrated into a smaller area, making any one spot brighter, or is spread over a larger area, giving less light to any particular spot. With a manual unit that means you will have to calculate a new f-stop or a different working distance. Many automatic flash units will compensate for the exposure change without requiring an aperture change, but the working range for the f-stop in use will change.

The change in flash output or efficiency caused by altering the coverage is usually given as a changed guide number. Here is an example; the data come from the chart supplied on an actual automatic flash unit with a zoom head:

| Zoom Head Setting | Matches Coverage of Camera Lens | | Guide Number (ISO/ASA 25 Film) | Automatic Flash Control Range |
|---|---|---|---|---|
| Extra wide | 28 | mm | 23 | 5–23 ft |
| Wide | 35 | mm | 33 | 6.6–33 ft |
| Normal | 50 | mm | 40 | 8.3–40 ft |
| Telephoto | 105 | mm | 47 | 10–47 ft |

Notice that the closest distance as well as the farthest distance increases as the flash angle of coverage narrows. The data are different for various flash units, so read your unit's instructions carefully to get proper exposure with other than normal coverage.

A wide-angle attachment or zoom head setting will actually let you use a wider lens than the unit is matched for—21mm instead of 28mm, for example—if you can accept slightly underexposed picture edges. With telephoto flash you can easily use a longer focal-length lens than the unit is matched for, because its field of view will be well within the flash coverage area. This is especially valuable when you are far from the center of interest but want a tightly framed picture.

## Technique Tip: Creative Use of Flash Coverage

You can use telephoto or wide-angle flash coverage for expressive effect in pictures and for creative exposure control. The way to do it is to mis-match the flash and the camera lens: use telephoto flash with a wide-angle camera lens, or wide-angle flash with a normal or telephoto camera lens.

For example, if you use a 90mm or 105mm flash setting with a 28mm or 24mm lens on the camera, you'll get a picture that is bright in the center and darkens toward the edges. If the ambient light is not very strong, your subject will be seen in a pool of light. This is especially useful to isolate a subject from "busy" or uninteresting surroundings.

Wide-angle flash lowers the guide number; that can let you use a larger f-stop to get reduced depth of field with any lens you choose. This is an easy way to achieve selective focus even with high-power flash units.

Wide-angle flash is also useful for working with highly polished surfaces, or working close to very reflective objects. These may cause an auto-flash sensor to shut down too soon. The wide-angle setting will diffuse the light, reducing the intensity of the reflections, and the flash will work as it should.

For a spotlighted effect with flash, use a tele-flash adapter or tele setting of a zoom-head flash unit and a camera lens that has a wider coverage angle. You can also improvise a tubular mask or "snoot" to cut down the flash coverage. Photo: R. Farber.

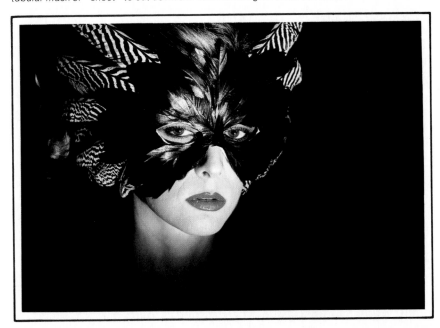

# 7

# Closeup and Macro Flash

Magnified images are fascinating. They isolate and enlarge tiny subjects so we can give them undivided attention, and they reveal details barely visible to the unaided eye. Closeup pictures are those in which the size of the image on the film is from one-tenth to about one-half the actual size of the subject. In macro pictures the image size on the film ranges from the same as the subject size to several times larger. To get these kinds of photographs you usually must bring the lens very close to the subject, and you must use a large amount of light for proper exposure.

Pocket-size electronic flash units are ideal for this work. They are so small and lightweight that it is easy to position and move them. They produce plenty of light at close distances without heat that could injure the subject, in a burst so short it can freeze any subject or camera movement. And they are inexpensive.

The best flash units for closeup and macro photography are non-automatic models with low guide numbers. The next choice is one or more thyristor-circuit automatic units that offer variable output control in the manual mode by means of shortened flash duration. In general, manual units are the easiest to control with precision. Automatic units can be used for closeups, but in macro set-ups they may be so close to the subject that even the shortest burst the sensor allows produces too much light.

Lighting methods for closeup and macro photographs are quite similar to those used for flash pictures taken at normal distances. Dimensional lighting, direct or bounce light, and multiple flash are all usable. The greatest problem is determining exposure accurately.

In most closeup and macro situations, lens f-numbers and flash guide numbers change from their normal-distance values. Auto-flash control is likely not to be precise, and only through-the-lens flash metering can take all the variables into account; few cameras offer this feature. So, you will need to do a little figuring—that and some trial-and-error experience can give you truly outstanding results.

*Most close-ups by flash require somewhat diffused light to avoid harshness. When there is incised detail such as the marking on the micrometer, or low relief texture such as that of the background material, the light must skim across the subject at a low angle to bring them out most clearly. Photo: J. Sarapochiello.*

*Close-up methods. (Left) Supplementary lens or close-up attachment. (Opposite page, left) Lens with built-in extended ("macro") focusing capability. (Right) Accessory bellows unit for lenses with normal range focusing mounts and lenses in non-focusing mounts.*

## Getting Close

The four basic ways of getting closeup or macro pictures are briefly described here. Your major concerns in choosing a method should be to utilize your present equipment to best advantage, to avoid unnecessary exposure problems, and to obtain adequate working room between lens and subject.

**Supplementary Lenses.** A simple way to get a magnified image is to add a positive supplementary lens (a "closeup attachment") in front of the camera lens. This shortens the effective focal length of the camera lens so you can focus sharply at a closer than normal distance. Supplementary lenses for closeups come in various powers: +1, +2, +3, etc. A higher power lets you get closer for a bigger image, but not close enough for macro range magnifications. Supplementary lenses require no special exposure compensation, but they seldom equal the optical quality of your camera lens. You usually will need to use at least $f/11$ or $f/16$ for reasonably sharp results.

**Lens Converters.** A lens converter or extender is an optical accessory that is used between the camera body and the lens. It multiplies the lens focal length—and therefore the image size—by its own power: $1.5\times$, $2\times$ or $3\times$. The result is closeup but not macro-size images. An extender does not change the minimum focusing distance of the lens,

but it does multiply the $f$-numbers. With a $3\times$ extender, $f/8$ really has a value equal to $f/24$. You must take that into account when computing exposure.

**Macro-focusing Lenses.** A number of modern lens designs have so-called macro focusing. That is, they focus continuously from infinity down to distances that produce images about half life-size without the use of any accessories. In fact, most such lenses do not reach into the macro range unless an extension ring is added. Most "macro" zoom lenses must be used at their shortest focal length when shifted into the close-focusing range. Some macro-focusing lenses automatically compensate for the change in $f$-stop values in the close range, others require manual compensation.

**Extensions and Bellows.** For true macro photography (technically, photomacrography) you must mount the lens a greater than normal distance from the film. One way is to insert extension rings or tubes between the lens and camera body These accessories have no optical elements, they simply extend the lens mount. To achieve various extensions you can combine rings or tubes of different lengths, or you can use a telescoping "zoom" extension tube.

An accessory bellows provides a continuous range of extensions out to its maximum length—only about 90mm (3½") in some models for 35mm cameras, but as much as 200mm (7⅞") in others. While not as rigid as extension tubes, a well-made bellows is far more versatile. Whichever method you use, extending the lens mount changes $f$-stop values and you must compensate the exposure accordingly.

## Basic Closeup Lighting

Lighting for closeup and macro work can be set in several different arrangements: symmetrical, architectural, skim, axial, transmitted, and tent. Some of these arrangements are suitable for both three-dimensional and two-dimensional subjects; the latter are most often encountered in copying.

A strong flash from behind brought out the hairlike spicules at the edges and revealed veining by transmitted light. A reflector in front helped light less translucent portions. Photo: C.M. Fitch

Light from a single unit to the left, at a low angle, outlined the body and illuminated the background so that the delicate structure of this dragonfly's wing showed clearly in silhouette. The warm color results from using tungsten type color film with electronic flash. Photo: K. Bancroft.

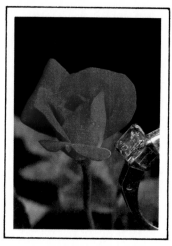

The diamond ring was included to give an idea of the size of this delicate rose. A single diffused flash unit was a bit right of the camera, at a high angle; a reflector was at a low angle, at the left. Compare this with the pictures at the bottom of the opposite page to see how the choice of a background sets off subject color to best advantage. Photo: C.M. Fitch.

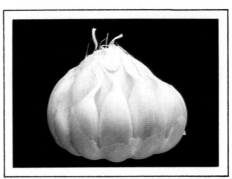

There are two ways to achieve this effect: (1) Use a ringlight (see next page) with the subject on black velvet. (2) Use a diffused flash at a very high front angle, almost a top light, and a more diffused flash below. Suspend the garlic on a hidden stiff wire protruding directly from the background. Photo: C.M. Fitch.

(Right) Strong, direct top light from the left and a bit behind the mushroom; diffused fill light from a low angle at the right. (Below left) Diffused flash from the left, at lens level; diffused top light from the right, almost directly overhead. (Below right) Direct flash on the leaves, from left. Diffused top light from behind, right. Diffused front light from the right, at blossom level. Photos: C. M. Fitch.

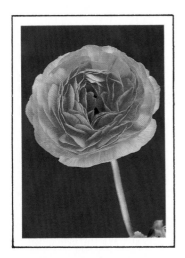

## Special Lighting Set-ups

Certain kinds of subjects require special lighting to bring out their characteristic qualities most clearly. The delicate structure or coloring of a translucent subject is best revealed by transmitted light. Objects with smooth, highly reflective surfaces often look best with tent lighting. Those with recessed portions, or designs in low relief, such as coins, require axial lighting—illumination that travels along the axis between lens and subject.

**Ringlight.** A ringlight is composed of a circular flashtube and reflector. The center of the circle is large enough for a lens to look through. Small ringlights can be mounted directly on the lens with clamps or with threaded adapters, like a filter; large ringlights require separate support. Most ringlights have separate power supplies in order to keep down their size and weight. A few have auto-flash sensors, but most are manual flash sources. The illumination from a ringlight is shadowless because it comes from all directions. You can create some directionality and modeling by blocking off a portion of the tube with black tape, or by reducing the intensity of one portion with layers of diffusing or neutral density material. (See the later section, One-stop Exposure Control.)

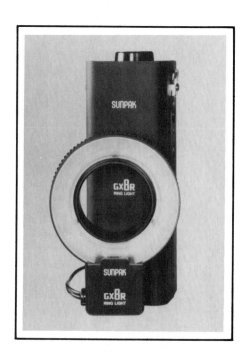

The color and delicate detail in this closeup are revealed by a combination of transmitted and reflected light. A ringlight directly behind the leaf provided even illumination to shine through and make the colors glow. A direct flash in front was triggered by a slave switch reacting to the righlight output. As the slight shadow along the central vein reveals, it was positioned slightly to the left. Photo: C.M. Fitch

Opposite page:
Most ringlights have a separate power supply in order to reduce the bulk and weight of the light head which mounts around the camera lens. The axial light from a unit like this eliminates all shadows on subject surfaces facing the lens—a kind of illumination that is a s useful at normal subject distances as it is close up.

## Flash Distance and Exposure

In closeup and macro work, the near-to-far zone of sharpness around the subject (the depth of field) is very shallow. The greater the magnification, the less depth of field you have, but at any given distance you can increase the depth of field by using a smaller *f*-stop. In practical terms, you often must use $f/11$ or $f/16$ for any reasonable degree of depth of field in macro set-ups. That means you must control exposure by adjusting the flash distance instead of the usual procedure of changing *f*-stop. Here's how, with lenses on extension tubes or bellows:

1. Reduce your flash guide number to three-quarters of its usual value (multiply GN by 0.75). This is necessary because guide numbers are calculated for normal distances and for the light reflected by the surroundings. These factors do not apply in closeup/macro work.
2. Multiply the reduced GN by 12 so you will get set-up distances in inches rather than fractions of a foot. This is your closeup guide number (CU GN). (If you use metric guide numbers, multiply by 100 for cm, or by 1000 for mm measurements.)
3. Set your lens to $f/11$ or $f/16$ and calculate the true or effective *f*-number, as explained in the section Magnification and Exposure.
4. Divide the CU GN by the effective *f*-number. The answer is the distance in inches (cm, or mm) from the subject to place the flash.

With *supplementary lenses* or *macro-focusing lenses,* use the CU GN of the unit, but divide by the *marked* *f*-number, not an effective *f*-number. Watch carefully for the changing *f*-values on macro-focusing lenses.

With *lens extenders,* calculate the CU GN in a different way. Divide the normal GN by the extender power ($1.5\times$, $2\times$, or $3\times$). Then divide the CU GN by the *marked* *f*-number of the lens setting. The answer will be in feet (or meters) unless you convert the guide number before dividing by the *f*-number.

If you are making a multiple flash set-up, use the above method to establish the key light position. Then work from the *f*-number you used with the key light (effective or marked number, depending on the equipment you use) to figure out distances for fill and other flash units —see the chapter on multiple flash. Be sure to calculate a CU GN for these other units and work with that.

**Checking Exposure.** If you have a flash meter, use it to check your intended exposure. In any event, bracket exposure extensively during your first attempts and keep careful notes of magnification, *f*-stop setting, and flash distances. Color slide film is your best choice

for tests because its processing is essentially invariable, and it reveals even slight exposure changes quite clearly. Bracket in half-stop steps up to two stops more and less than your original exposure. You'll soon be able to judge closely enough to cut that down a good deal.

**Adjusting Light for Exposure Control.** If the flash is too bright, you can reduce the light in three ways without changing set-up distances.

1. Place a wide-angle accessory lens or diffuser over the flash head. Check the flash instructions to see how much this reduces the normal guide number, and calculate the CU GN from that.
2. Place layers of white handkerchief or facial tissue over the flash head. Each layer reduces the light about one $f$-stop. Test shots, or comparison readings with a flash meter, can give you an accurate indication of the light reduction.
3. Place neutral density (ND) filters in front of the flash head. These are avaiable from photo stores. Each 0.3 of filter density reduces the light by one $f$-stop.

*You can adjust automatic flash distance for background control as well as subject exposure. To get a darkened background, move the flash back so that the subject is just within the far limit of coverage. To get a lighter background move the flash closer so that most of the coverage range extends beyond the subject. So long as the subject fills the sensor coverage area, it will be properly exposed in either case. Photo: C.M. Fitch.*

## Through-the-Lens Metering, the Easiest Control

Although it is difficult to use most automatic flash units in the automatic mode for precise exposure control in closeup/macro work, there is a major exception. That is a camera with built-in flash metering used with a dedicated flash unit. The flash unit can be positioned off the camera if you have a hot shoe extension cord that maintains all the camera's auto-control functions.

The beauty of this system is that it gives you automatic exposure control without any math problems. The meter reads light reflected off the film plane and controls the flash duration accordingly. All the effects of filters, *f*-stop, and extra extension are taken into account. In addition, this system means that multiple flash set-ups *on automatic* are possible.

You must exert some control, however. The camera meter assumes every subject to have average reflectivity. If the subject is quite light colored, you must fool the camera into giving a half or a full stop more exposure. If the subject is dark colored, you must fool the camera into giving less exposure. The meter would try to make them both the same brightness, and the exposure of each would be wrong. To fool the camera, change the film speed setting. Cut the ISO/ASA speed in half to get one stop more exposure; double the speed to get one stop less exposure. Do not change the lens *f*-stop; that will only cause the meter to make the flash unit put out more or less light.

*The meter cell visible through the film gate reads light reflected from the film during exposure. With a dedicated flash unit, it can provide close-up exposure control in almost all situations. Normal-range control with flash and other light sources is also provided.*

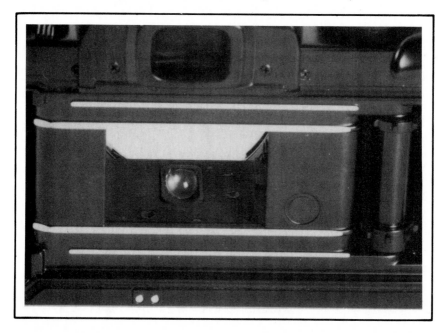

*This auto-flash sensor clips to the front of a lens for readings directly from close-up subjects. It connects to its flash unit with an optical-fiber cable so that the flash can be placed in the best position for any kind of subject.*

## One-stop Closeup Exposure

It is often possible to use a single *f*-stop for properly exposed pictures throughout the closeup range, from 0.2× to 1× or life-size (see the section Magnification and Exposure for an explantion of image size). The technique is to use a lens mounted on a bellows, and to mount a small flash unit on or beside the lens. As the bellows is extended or retracted, the flash unit moves with the lens. The technique is equally suitable with a conventional unit or with a ring light.

As explained in the discussion of magnification, *f*-values change as a lens is extended for very close focusing, and more light is needed to maintain consistent exposure. When the flash is mounted with the lens, each change in extension moves the light source an equal amount. The two factors balance one another, so you can use the same *f*-stop at all extensions.

You will need to test this arrangement to arrive at the best *f*-stop. If you buy a lens-mount closeup flash outfit, use the *f*-stop suggested by the manufacturer. If you make your own arrangement, multiply the guide number of a small, low-guide-number manual flash unit by 1.2 and use the answer as an *f*-stop setting for tests. Bracket exposure at several different closeup positions, from minimum to maximum bellows extension. Keep careful notes. Examine the processed results and choose the best exposure in each case. You will find that one *f*-stop will be best in practically all cases, with perhaps only a half-stop adjustment necessary at the extremes.

## Magnification and Exposure

Because you cannot always rely on auto-flash exposure control for closeup and macro pictures, you will sometimes need to figure out some information. Fortunately, that is easy to do; everything you need to know is related to how big the image is—its magnification.

**Magnification.** Even when the image on film is not larger than the actual subject (its life size), we refer to the image scale as magnification. A one-quarter life-size image has a magnification (M) of $\frac{1}{4}$X or 0.25X; in an image three times bigger than life, M = 3X. (To get the actual image size, multiply the subject size by the magnification factor.)

Another way of expressing this is as a reproduction ratio between image size and object (subject) size—1:4 and 3:1 in the above examples. The relative image size is always given first, the relative object size second. The smaller of the two is made equal to 1, so you can tell immediately how many times bigger the other factor is. (A ratio is just another way of writing a fraction; 1:4 = $\frac{1}{4}$; 3:1 = 3/1 = 3; etc.)

**Determining Magnification.** Magnification scales marked on lens barrels or extension accessories are often inadequate; measuring lens-film and lens-subject distances to determine magnification is likely to be inaccurate. Here is a simple way:

1. Place an inch or millimeter scale where you have focused at the subject position. Turn the scale so it runs straight across one dimension of the viewfinder frame.
2. See how many inches (or mm) are visible across the viewfinder frame.
3. Divide the viewfinder frame dimension by what you see; the answer is the magnification.

Use the short dimension of a 35 mm camera viewfinder because it is almost exactly one inch (or 25 mm) and that makes it easy. For example, if you see two inches in the viewfinder, M = $1 \div 2$ = $\frac{1}{2}$ or 0.5X. If you see a half-inch, M = $1 \div \frac{1}{2}$ = 2X.

To determine magnification by the viewfinder method described in the text, the ruler must be at the subject distance, not significantly closer to or farther from the lens. Magnification indicates the image scale on the film. When you project a slide or make an enlarged print, multiply M by the degree of enlargement to get the display image magnification. Photo: C. M. Fitch.

**Exposure with Extensions.** When you take pictures that are one-quarter life size (¼X, 0.25X, or 1:4) or bigger, you must add exposure compensation if you use extension tubes or bellows. This is because the lens is farther than usual from the film, and the image-forming light loses intensity over the increased distance. To figure the required exposure increase (EI), use the image magnification this way: $EI = (M + 1)^2$.

For example, if $M = 3$, $EI = (3 + 1)^2 = 4^2 = 16$. That means you need 16 times (four stops) more exposure than for a normal-distance picture. The accompanying table will simplify things for you. Since you cannot change shutter speed for exposure control with electronic flash, you must open the lens the required number of stops, or add light for an equivalent increase (see Increasing the Light Level in Chapter 5).

## EXPOSURE INCREASE WITH EXTENSIONS

| M | EI | =Stops* | M | EI | =Stops* |
|---|---|---|---|---|---|
| ¼X (0.25X) | 1.56 | ½ | 3X | 16 | 4 |
| ½X (0.5X) | 2.25 | 1 | 4X | 25 | 4½ |
| 1X | 4 | 2 | 5X | 36 | 5 |
| 2X | 9 | 3 | 6X | 49 | 5½ |

*To nearest half-stop.

**Effective f-number.** When you use extension tubes or bellows, marked f-numbers change value in closeup and macro work. You need to know the effective f-number (Ef) of each stop to determine flash set-up distances accurately. Figure it this way:

$Ef$ = Marked f-no. $\times$ (M + 1).

For example, if $M = 3$, the $f/4$ lens setting has a true or effective value of: $f/4 \times (3 + 1) = f/4 \times 4 = f/16$.

(NOTE: The above methods apply to lenses with symmetrical optical design—normal focal-length camera lenses, and lenses in non-focusing short mounts designed especially for use with a bellows. If you plan to use a non-symmetrical design—a telephoto or wide-angle lens—see the appendix.)

**Exposure with Other Methods.** *Supplementary lenses:* No exposure compensation required. *Lens converters or extenders:* Divide the flash guide number by the extender power, then use the marked f-numbers on the lens. *Macro-focusing lenses:* If changed f-numbers are given for focus (and zoom focal length) changes, use them to figure exposure. If no corrected data are given, determine M and EI as described above.

## Working Distance

Working distance is the space between the lens and the subject. It is important in closeup and macro photography because there must be enough room to get lighting units into position, and the camera must not cast a shadow into the field of view. Often you can just focus at the magnification you want and see what the resulting working distance is. Sometimes, however, it is much easier to choose equipment and make a set-up if you know the working distance beforehand.

**Macro-Focusing Lenses.** The close-focus distances marked on most macro-focusing lenses (or given in the instructions) are measured from the film plane. But the useful working distance is from the front of the lens to the subject. So, measure the distance from the film plane symbol (-0-) on your camera (or measure from the camera back, the difference will be slight with 35mm cameras) to the front of the lens when the lens is set at the most extreme close focus. Subtract that measurement from the distance supplied by the lens data.

**Lens Converters or Extenders.** A converter does not change the focused distance, it simply enlarges the image. Determine working distance as you would with a macro-focusing lens: subtract the focal-plane-to-lens-front measurement from the distance given on the lens barrel.

**Supplementary Lenses.** See the Technique Tip.

**Lenses Plus Extensions.** You can figure working distance (WD) for lenses mounted on extension tubes or bellows by using the lens focal length (F) and the image magnification (M) this way:
$$WD = F(M + 1) \div M.$$
That is: add one to the magnification, multiply by the focal length, and then divide by the magnification. For example, if $M = 1.5$ and $F = 50$mm, then WD = $50(1.5 + 1) \div 1.5 = 125 \div 1.5 = 83.3$ mm ($3\frac{1}{4}$ inches).

The answer you get is the distance from the lens diaphragm to the subject with normal focal-length camera lenses and short-mount bellows lenses. It is the distance from a bit behind most wide-angle lenses. You can measure between those points and the front of the lens and subtract that from the working distance calculation if you want increased accuracy.

Telephoto lenses are a different case. Because of their optical design you may get more working distance than your figures indicate. To find out, mount the telephoto lens on the camera without extensions and focus it at infinity. Measure from the film plane forward a distance equal to the focal length of the lens. If that falls in front of the lens,

you can add the distance from that point to the front of the lens to your working distance figures. If it falls within the length of the lens, measure from that point to the front of the lens and subtract that from your working distances.

**Increased Working Distance.** To get more working distance, change to a longer focal-length lens; the distance will change proportionately—twice as much working distance with double the focal length, three times as much distance with triple the focal length, and so on. However, if you are using extension tubes or bellows, their length must also increase proportionately—double, triple, etc.

# 8

# Special Equipment

A number of flash units and accessory pieces of equipment are made for special purposes. Some of the most popular items of this sort are described in this chapter to help you find what you need for your own photographic work.

**Barebulb Flash.** A barebulb flash unit has an exposed flashtube with no reflector; its light radiates in every direction. A single barebulb unit used above the camera can completely illuminate a small, light-colored room because the light is reflected from all surfaces. Using more than one barebulb units makes it easy to light up large areas. Because there is no reflector to shape the light beam, barebulb flash permits use of ultrawide-angle camera lenses without light falloff at the edges of the frame. A barebulb unit is also an excellent light source for very closeup and macro photography. When placed for "architectural" lighting, it gives good modeling and texture, and there is plenty of light to be picked up by a reflector for use as fill.

In addition to barebulb-only flash units, there are standard units with removable reflectors for conversion to barebulb use. Other flash units accept a plug-in barebulb tube on top; it may be fired with or without the main flash tube in some models.

Most barebulb flash units are manual; the few automatic units require that the tube be used for bounce light and rotated so that no direct light can hit the sensor. It is virtually impossible to assign a meaningful guide number to a barebulb unit because there is no way to predict what the surroundings will be—small or large room, light or dark colors, outdoors—all have vastly different reflective characteristics. A flash meter is very useful; otherwise you must rely on test shots and experience.

If you use a barebulb unit off camera, use a deep lens shade as well. Light from the barebulb may cause flare if it hits the lens directly.

*Electronic flash is ideal—and essential—for color photography underwater, whether you are only at 15 or 20 feet, or are deeper, on the ocean floor. Some aspects of underwater flash are covered on pages 108 and 109. Photo: H. Taylor.*

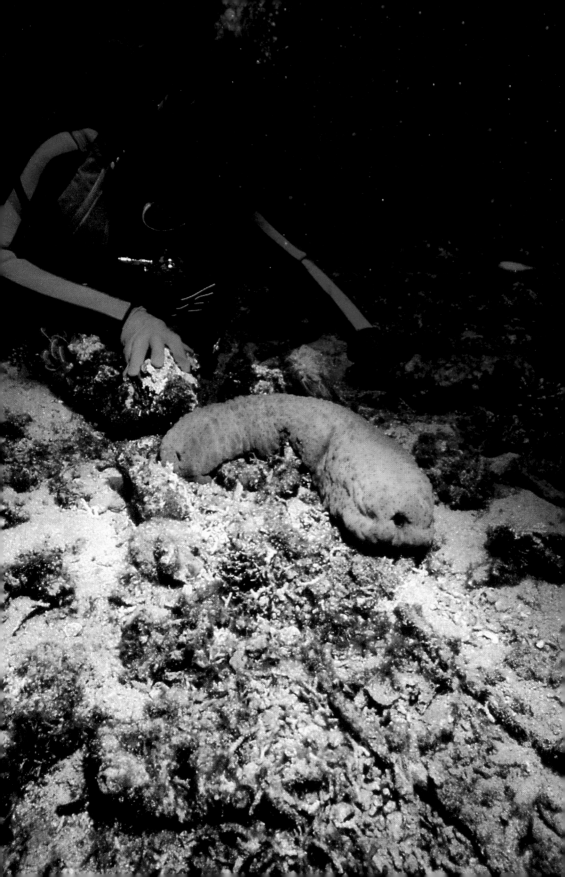

## Flash Meters

A flash meter is an exposure meter with circuitry that can respond to the extremely brief burst of light characteristic of electronic flash, typically from 1/500 to 1/30,000 sec. Some conventional light meters have flash-reading accessories.

A flash meter is ideal for determining exposure with multiple flash set-ups, barebulb flash, closeup and macro work, and all kinds of unusual, non-standard conditions. Most flash meters are incident-light meters. You hold the meter at the subject position and aim the light collector at the camera position while the flash is fired. Depending on meter design, a moving needle or an LED display will indicate the required *f*-stop, or will indicate a light value which you transfer to a calculator dial to determine the *f*-stop, as with some conventional meters. Of course the meter first must be set to the proper film speed.

Some flash meters also permit reflected-light readings, or have other features such as reading ambient light plus flash, or building a cumulative reading from repeated flashes.

One of your major considerations in choosing a flash meter should be whether it requires cord or cordless readings, or permits both. A cord-type meter is excellent for studio and other limited-distance work, and for working alone. The meter is connected to the master flash unit by an extension sync cord; when you push the meter switch for a reading, it fires the flash. A cordless meter gives you much more mobility and therefore is quite useful on location.

*This highly versatile flash meter offers both cord and cordless operation. It can read reflected or incident daylight and artificial light as well as flash. Readings are shown by LED numerals. For cordless incident-light flash readings, you can have an assistant fire the flash while you handle the meter. Or, you can temporarily use a slave switch on the flash and trigger it with a low power battery flash from the meter position. Be sure to shield the meter from the trigger flash.*

## Strobe Light

A stroboscope is a highly specialized electronic flash unit that can fire repeatedly several times a second. Thus, during a long exposure, many images will be recorded on a single frame. The effect is meaningful only if the subject, the camera, or both, is in motion. Sequences showing a drop of liquid splasing, a bullet in flight, a tennis or golf stroke, and similar actions are photographed by strobe light.

Almost all stroboscopes are a.c.-powered. In order to achieve fast recycling, they have a very large power supply and a small capacitor. The result is quite low light output, which is usually concentrated into a very narrow-angle beam to keep intensity as high as possible.

Some popular stroboscopes used for discotecque, stage, and display effects have an uneven rate of flashing. Industrial and photographic stroboscopes have a regular rate of equal-length light bursts occuring at equal intervals. The least expensive units have a fixed rate, other permit varying the number of flashes per second. Photographically usable rates are about 50 times a second and faster; some units achieve 2500 flashes per second. Flash durations may be from 1/40,000 to one billionth of a second, depending on the unit.

**Working with Strobe Light.** When photographing with a stroboscopic light source, keep the following in mind:

1. Limit the flash-to-subject distance as much as possible to reduce the need for a wide lens aperture, which would result in little depth of field.
2. Flash duration is so brief that the film may exhibit reciprocity effect—failure to build up normal exposure. If you know the flash duration, consult the film manufacturer; otherwise, shoot tests at various $f$-stops.
3. Keep ambient light very low to avoid ghost images. You want only those images lighted by the flashes to record on the film.
4. Use subjects of light color or high reflectivity; keep backgrounds uncluttered and dark or black.
5. Check the restrictions on the stroboscope operating time. Some units can be used continuously over relatively long periods, others units must be rested to cool off after a certain period of operation.
6. Too fast a strobe rate in relation to the speed of subject movement will cause images to pile up on one another. Experiment with various strobe rate and subject movement combinations to get a feel for what will give you the clearest, most interesting sequence images.

## Underwater Flash

Most underwater pictures are taken with some kind of artificial light. This is necessary because natural light decreases rapidly as depth increases; in addition, its color content is reduced. Red is filtered out by the time you get to 6 meters (20 feet) depth, orange by 9–10 meters (30–35 feet), yellow by 18–20 meters (60–65 feet); at about 27 meters (90 feet) the scene is a dim blue-gray.

The easiest way to overcome this problem is to take light down with you. There are battery-powered continuous light sources, and flashcube or stripflash units for underwater use. But electronic flash units offer high intensity in a small size without a limit on the number of flashes possible.

**Ordinary Units.** Many on-land types of electronic flash can be used underwater with the appropriate watertight housing. A guide number of over 50 (for ISO/ASA 25) is recommended, as is a supplemental triggering device. The triggering device aids in combating the twin problems of moisture in the camera-to-flash connectors and the high resistance of the heavy duty flash cords that should be used with underwater flash housings.

Automatic units should be used in the manual mode only. If used on automatic, the flash sensor will detect light reflected within the housing and shut down the unit too quickly.

**Underwater Units.** Electronic flash units designed specifically for underwater use do not require special housings. Some are automatic and some have twin heads, built-in modelling lamps, circular flash tubes, slave units for remote firing, and variable power options. The most important feature is protection against moisture and pressure changes. This is provided by a special "O" ring which protects the delicate internal electrical components, extra-heavy-duty cords and extra-strength exterior components.

Automatic underwater units use external sensors that stay on the camera while the flash is aimed elsewhere.

**Lighting Problems.** Whether using a land unit, flashbulbs or special underwater units, the best way to approach lighting a scene is as if the light were not artificial—this means the light should come from overhead. For texture and modelling, the flash can be held off camera, high and to the side, pointing down at an angle of 45 degrees.

"Backscatter" is one of the commonest problems in underwater lighting. No matter how clear the water may seem, there are suspended particles that may become visible when hit by light. If a flash unit is at the camera, pointing straight ahead, the chances of backscatter are much greater than if it is off camera, pointing down from an angle of 30 to 45 degrees.

*Underwater electronic flash units like these have built-in pressure and waterproofing features. The sync cords have special leakproof connectors to attach to the camera housing. The unit at the left has a table for determining manual exposure; the unit at the right offers auto-exposure control at two f-stops. Useful flash range underwater depends upon clarity of the water.*

**Exposure Considerations.** Underwater, the guide number of an electronic flash unit or bulbs is cut to about one-half or even one-third of what it would be on land. For light-colored subjects, try dividing the on-land guide number in half; darker subjects may call for dividing the guide number by three. Bracketing is strongly recommended, as is the use of a flash meter "suited up" in an appropriate underwater housing.

When calculating an *f*-stop from the flash-to-subject distance, another phenomenon must be kept in mind. Underwater, actual distance is about one-third greater than the apparent visual distance. An object that appears to be at 10 feet will actually be at about 13. If you are using a rangefinder or a single lens reflex camera, rely on the actual distance setting on the lens. But if you are estimating the distance, increase your guess by one-third. Divide that into your unit's underwater guide number to find the appropriate *f*-stop.

Flash coverage is reduced under water by as much as 25 to 40 percent. If you are going to use a wide-angle lens, learn what its underwater coverage is and be certain that the flash you use along with it has sufficient coverage. Unfortunately, the only way to determine this is by actual tests, especially if you are using a unit normally designed to be used above the water with a 50mm lens. If you find that the angle of illumination is too narrow, it may be necessary to use two electronic flash units: one fired by the camera, the other by a slave trigger.

**Equipment Care.** No matter what type of flash equipment you choose, be sure that it is throughly cleaned after each dive. If you have been in salt water, the unit should be submersed in fresh water—not just rinsed off. "O" rings should be checked and relubricated if necessary. Recharge batteries so they're ready to go for the next dive. It doesn't make a lot of sense to go on a dive with a camera loaded for 36 exposures and find yourself with only enough power in your electronic flash unit for a few shots.

# 9

## Flash Questions and Problems

At times as you use flash equipment, you may get variations in your results that will make you wonder whether everything is operating properly. Here is some information about checking and caring for your equipment. Whatever you do however, stay out of your electronic flash unit. That is, do not open it up to examine interior components. The capacitor in even a pocket-size unit stores enough power to injure you quite badly; some larger units can kill you. Leave inside work to an experienced repair person.

**Checking SLR Synchronization.** If you suspect that the X (electronic flash) synchronization with your focal-plane shutter camera is not functioning properly, run this test: Unload the film, set the lens at its largest aperture, set the shutter to its sync speed, and connect the flash unit. Point the camera at a white or light-colored wall and look through the open back of the camera. Press the shutter release. You will see the entire focal plane rectangle (the film gate) illuminated by the light reflected from the white wall. If you find it hard to ignore the light bouncing back around the camera, poke the lens through a hole in a large sheet of cardboard or a slit in a piece of dark cloth large enough to mask the wall from your immediate view

If you do not know the sync speed of your camera, start at 1/125 sec. In either case, if you do not see the full film format rectangle lighted up, the shutter is at too high a speed, or is operating improperly. Try lower speeds, one at a time. If you continue to get cut-off, have the shutter repaired.

You can also perform this test photographically, using slips of enlarging paper in place of film—it is quick and easy to process the paper after each shot. With proper sync operation you will get a full film-area dark gray or black rectangle.

A properly operating electronic flash unit makes it easy to freeze action like this. As explained in this chapter, you should frequently check synchronization, capacitor form, battery condition, and connecting cords to ensure troublefree photography. Photo: M. Frank.

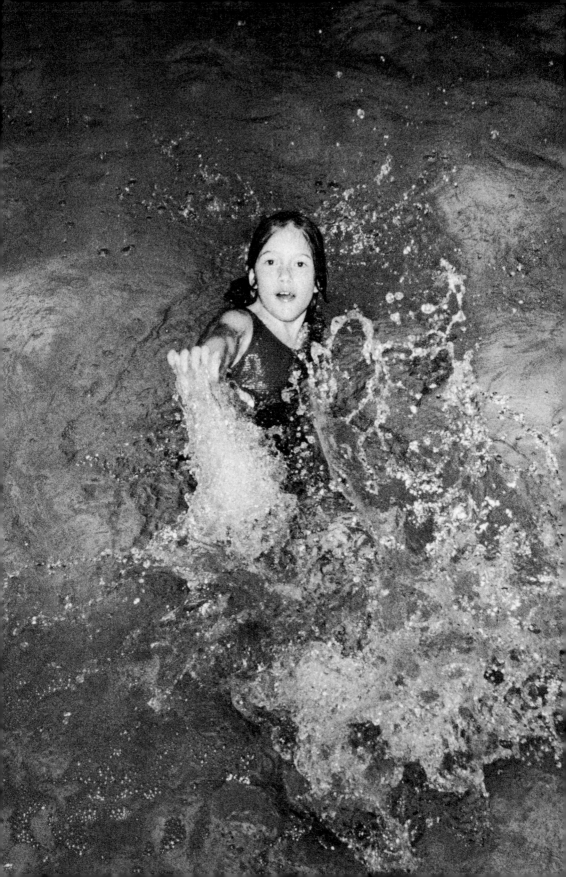

## Capacitor Care and Feeding

Capacitors, like humans, have to be fed periodically. They eat electrical energy; without it, they die. If your unit has been sitting on a shelf for several months it may take some time (and a great deal of feeding) to bring it back up to a good working condition.

Most electrolytic capacitors are made up of sheets of aluminum foil and electrolyte-impregnated paper rolled into cylindrical form. When current is applied, a layer of aluminum oxide is formed which permits the capacitor to hold electrical energy. When current is removed, the aluminum oxide starts to dissipate and finally becomes thin and full of holes. These holes permit the electrical energy to leak out. The amount of time it takes for this thinning process is dependent on how thick the aluminum oxide layer was to begin with and the temperature at which the unit has been stored. The weaker the charge and the higher the storage temperature, the faster the breakdown process.

**Storage.** To avoid capacitor breakdown, store your flash unit with the capacitor fully charged (do not fire it after your last shot), but without batteries, in a cool place. Some experts even recommend refrigerator storage, after first sealing the unit in a moistureproof wrapping.

Do not leave your flash unit in storage without attention. Turn it on, without firing it, for five minutes or more a month. Use a.c. for this job if possible, or use older batteries you have put aside because they were not recycling the unit fast enough. They are ideal for this application.

**Reforming.** If you do not take these precautions, you will have to rebuild the aluminum oxide barrier in the capacitor from time to time. Otherwise, any electrical energy you feed into it will leak out rapidly. The process is called reforming the capacitor.

If you have an a.c./battery unit, use a.c.; there is no sense in using up batteries for this purpose. If it is a battery-only unit, use fresh batteries or newly charged ni-cad cells. Simply plug the unit in and let it "idle" (ready light on, with no demands for a flash) for at least 30 minutes. Then proceed to use the unit normally. Remember to recharge your batteries after reforming a condenser; it takes a good deal of power.

## Batteries

Zinc-carbon, alkaline manganese, nickel-cadmium and lead-acid batteries can all have the same outside dimensions but different characteristics. Each type can supply only a certain amount of energy before it must be replaced or recharged. In the main, alkaline manganese batteries will deliver 50 to 100 percent more flashes per set than their nickel-cadmium counterparts. Conversely, nickel-cadmium cells offer faster recycling times (often twice as fast) than alkalines and can be reused after recharging. These two types are the most popular with electronic flash users.

Zinc-carbon cells can be used in electronic flash units, though they are not recommended for units using AAA, AA, C, or D cells. They offer slow recycling times and only a fraction of the number of flashes possible with comparable alkaline manganese or nickel-cadmium cells.

Lead-acid batteries are used primarily with larger handle-mount units and can be packaged in many configurations depending on the requirements of the manufacturer.

Read your unit's instruction booklet carefully to determine what type of battery it accepts. If you have one that uses only rechargeable nickel-cadmium batteries, *do not* replace them with alkaline manganese, zinc carbon or other types of cells. They may be the same size, but not the same voltage.

Nickel-cadmium batteries are nominally rated between 1.2 and 1.25 volts, while alkaline manganese and zinc-carbon cells have a 1.5-volt rating. If your unit is only designed to take 1.5-volt batteries, it is not advisable to use rechargeable nickel-cadmium cells. The unit may work, but not as well as with the other batteries.

---

 ***Technique Tip: Battery Precautions***

No matter what type of battery you use for your electronic flash unit, observe the following rules:

1. Recharge batteries in the appropriate charger for only the amount of time specified by the manufacturer.

2. Never recharge a battery that was not designed for that purpose.

3. Never carry small batteries loose in your pocket or gadget bag where they might come into contact with other metallic objects and short out.

4. If you are not going to use your flash unit for several weeks, remove the batteries and store them in a sealed bag in the refrigerator. It will slow their discharging rate.

5. Always clean battery terminals and flash contacts when installing new or stored batteries.

6. Use the correct battery in your flash unit; do not substitute another type unless the manufacturer states that it is permissible.

---

## PC Cords

PC cords (the initials are for Prontor/Compur, the German shutter manufacturers who standardized this coaxial pin connector) are the bane of many photographers. They can fall out, wear out, short out and otherwise cause a great deal of grief. A locking connector is preferable, and available for some equipment, but PC cords persist. So, here is a check list to help you. Ready light on, you're ready to fire the flash:

1. Is the PC cord securely pushed into the camera's PC terminal? If it is a detachable cord, is it firmly pushed into the flash unit sync cord socket?
2. Are the contacts clean?
3. Are there any obvious kinks or breaks in the cord, especially around the plugs?
4. Can you fire the unit using the "test" or open flash button? If so, the cord and camera are suspect. Try bending the outer metal sleeve part of the PC connector at the camera outward just a bit. Also, gently bend the inner prong slightly to the side—that may be all that's needed to make proper contact. (You can buy a PC conditioner for this purpose.)
5. Short out the cord using a paper clip or other metallic object. Place it against the inside prong of the cord. If the unit doesn't fire, the cord may be at fault. If possible try the cord with another unit you know to be in good working condition.

The PC cord may have a very high resistance. Let the unit sit in an "on" state for a couple of minutes, then try firing the flash. If the charge in the capacitor is high enough, it may overcome the resistance in the sync cord and fire the flash. This is, of course not a tenable condition so you should try to get a cord with a lower resistance. Take your unit to a camera store and try several different cord types until you find a good cord-to-flash match. This is not a common problem, but it could happen.

Finally, if shorting the PC cord fires the unit, you must suspect the camera's contacts. Try another flash unit; if the camera won't fire that one either, take the camera to a repair shop for a check.

## Troubleshooting Your Flash Unit

It can be very frustrating to take a flash unit out of storage, connect it to the camera, turn it on, and get either no ready light or a failure to fire. You can see the first problem immediately; you'll see the second the moment you try to take pictures, because you won't see a flash. Here's some checking to do:

### Readylight does not light.

1. Is the unit turned on? Does it have batteries, or is the a.c. cord firmly plugged in? Is the a.c. outlet hot?
2. Are the batteries in good condition? If they show no leakage at the terminals or along the seam, try cleaning the terminals and the contacts in the flash unit with a pencil eraser. If you have a battery checker or a volt meter use it. If they are low-voltage batteries (1.25 to 1.5 volts), make the "tongue test." Wet your finger and put it against the negative (flat) end of the battery while touching the positive (tipped) end to your tongue. A slight tingle or a "salty" sensation means they are not dead, but they may not have enough power to charge the unit. Try fresh batteries.
3. Is the capacitor formed and charged? See the earlier section on capacitor care and feeding.

### Readylight on, unit does not fire.

4. Is the camera set to X sync and the shutter set to the X sync speed? Some cameras will not fire the flash when set to faster than sync speeds.
5. If the unit is connected by a PC cord, is it all right? Check cord, plugs, and sockets as described on the facing page.
6. If it is a hot-shoe unit, is the unit foot fully and securely in place? Are the foot and shoe contacts clean? Scrub them with a pencil eraser.
7. Does your hot-shoe unit have a PC cord? If so, connect the unit that way and try it. If it fires, the problem is in the unit foot or the camera hot shoe.
8. Can you fire the unit using the open flash or "test" button? If so, the problem may be in the camera shutter contacts.

---

*A PC connector has a center prong and an outer metal sleeve which make individual contact for the two wires of a sync cord. The sleeve is split so its diameter can be expanded or compressed to get a snug fit in a PC socket. A PC tip conditioning tool is available which makes it easy to reform and resize a distorted tip; it is a delicate job with just a pair of pliers.*

# Appendix

In some situations you may want to calculate flash placement, exposure, and other factors rather than rely on automatic flash control or generalized rules of thumb. Some formulas have been given in the text. Here are some more formulas that may help you with special problems; all are easy to use with pencil and paper, or with a pocket calculator at most.

**Guide Numbers.**

$$GN = f\text{-number} \times \text{Flash-to-subject distance}$$

$$f\text{-number} = GN \div \text{Flash-to-subject distance}$$

$$\text{Flash-to-subject distance} = GN \div f\text{-number}$$

$$GN = \sqrt{0.05 \times \text{ECPS of unit} \times \text{Daylight ISO/ASA film speed}}$$
*(Answer is GN for distances in feet.)*

$$GN \text{ for feet} \times 0.3 = GN \text{ for meters}$$

$$GN \text{ for meters} \times 3.3 = GN \text{ for feet}$$

*GN for a different film:*

$$\text{New film GN} = \text{Old (known) film GN} \times$$

$$\sqrt{\text{New film ISO/ASA speed} \div \text{Old film ISO/ASA speed}}$$

*Practical GN test:* Photograph a subject at various $f$-stops with the flash unit 10 feet from the subject; use color slide film for greatest accuracy; keep notes. Examine the results. Multiply the $f$-number of the best exposure by 10 to get a true guide number for the unit. The test will give different results outdoors, where there are no nearby reflective surfaces, than indoors.

**Electronic Flash Output.**

ECPS or BCPS = $GN^2 \div$ (Daylight ISO/ASA film speed $\times$ 0.05)
*(Use GN for distances in feet.)*

**Magnification with Supplementary Lenses.**

*With the camera lens focused at infinity:*

M = Supplementary lens (+) power $\times$
Camera lens focal length in mm $\times$ 0.001

---

### SUPPLEMENTARY LENS LIMITS

| Camera Lens Focal Length | Maximum Useful Supplementary Lens Power |
|---|---|
| Up to 50mm | +10 |
| 60–75mm | +5 |
| 80–125mm | +3 |
| 135–250mm | +2 |
| 250–500mm | +½ |

---

### MAGNIFICATION WITH 50MM CAMERA LENS
#### Focused at ∞

| Supplementary Lens Power | Magnification* | Supplementary Lens Power | Magnification* |
|---|---|---|---|
| +½ | 0.025× | +6 | 0.30× |
| +1 | 0.05× | +7 | 0.38× |
| +2 | 0.10× | +8 | 0.40× |
| +3 | 0.15× | +9 | 0.45× |
| +4 | 0.20× | +10 | 0.50× |
| +5 | 0.25× | | |

*Image size on film will be this fraction of actual subject size.

# Appendix: Flash Calculations

## Exposure Increase with Wide-angle and Telephoto Lenses.

In a lens of symmetrical optical design, the diameter of the light path entering the lens that can pass through the diaphragm opening is the same as (or nearly so) as the light path emerging from the rear. However, in a lens of non-symmetrical design the two diameters are significantly different. Most wide-angle and telephoto lenses have non-symmetrical designs. The difference in the entrance and exit (pupil) diameters is called *pupillary magnification* (P). It can have a strong effect on the exposure increase required in closeup and macro photography when a non-symmetrical lens is used with extra extension.

*Pupillary magnification.* To determine the pupillary magnification, or P factor, remove the lens from the camera, adjust it to infinity focus, and close the diaphragm to a medium $f$-stop setting. Hold the lens several inches from your eye and sight through its front end, looking at a white surface. Use a ruler to measure the diameter of the diaphragm opening as it appears to you; this is the entrance pupil diameter. Now turn the lens around to sight through the rear and measure the diaphragm opening again. This is the exit pupil diameter. To calculate the pupillary magnification:

$$P = \text{Exit pupil diameter} \div \text{Entrance pupil diameter}$$

You can use the P factor and the image magnification (M) to calculate the closeup exposure increase (EI) factor. Depending on how you mount the lens, the procedure is slightly different. Normal mounting, with the lens facing forward, is suitable for the beginning of the closeup range. For very close shots and macro work, most camera lenses produce better sharpness when they are reverse-mounted so that the rear of the lens faces the subject.

*Normally-mounted lens:*

$$EI = \left[(M + 1) \div P\right]^2$$

*Reverse-mounted lens:*

$$EI = \left(\left[(P \times M) + 1\right] \div P\right)^2$$

Symmetrical camera lenses also give better macro image sharpness when reverse mounted, but the P factor has no significance. Calculate the exposure increase in the usual way: $EI = (M + 1)^2$

*Inverse square law: Light changes in proportion to the distance factor squared; this is because the area covered changes. If the distance doubles, the same amount of light falls on $2^2 = 4$ times more area; if the distance triples, it falls on $3^2 = 9$ times more area. As a result, any point on the area will be proportionately less bright. Brightness increases in the same proportion as the subject gets closer because the same amount of light is concentrated on a smaller area.*

## Depth of Light—The Inverse Square Law.

With direct flash, illumination changes as the flash-to-subject distance changes. When the width of the flash reflector is one-tenth or less of the subject width, or when barebulb flash is used, the degree of change in the light can be calculated from the new and old distances:

Light change factor = (Old distance ÷ New distance)$^2$

The answer tells you how many times the light has increased, or to what fraction it has been decreased.

You can also calculate how much more light a nearby subject is receiving than a more distant subject lighted by the same flash unit:

Light difference = (Far distance ÷ Near distance)$^2$

Use the following data to interpret this information in terms of exposure compensation.

| Light Change or Difference Factor | Exposure Correction (stops) | Light Change or Difference Factor | Exposure Correction (stops) |
|---|---|---|---|
| $\frac{1}{32}$X | +5 | 2X | −1 |
| $\frac{1}{16}$X | +4 | 4X | −2 |
| $\frac{1}{8}$X | +3 | 8X | −3 |
| $\frac{1}{4}$X | +2 | 16X | −4 |
| $\frac{1}{2}$X | +1 | 32X | −5 |

# Index